IMAGES
of America

OURAY

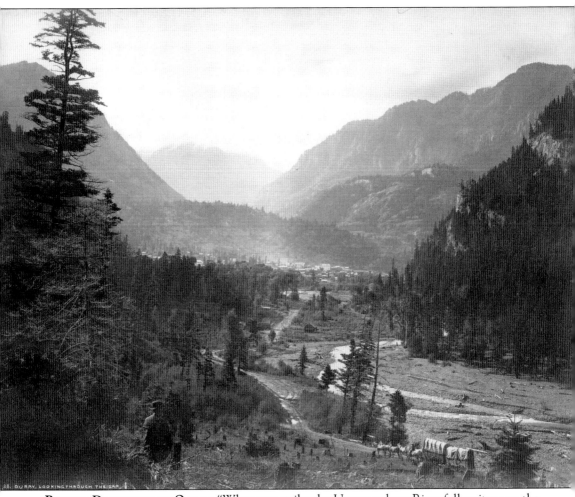

PIONEER DIRECTIONS TO OURAY. "When you strike the Uncompahgre River follow it up on the left hand side, keep goin' until you can't go no further, can't tell how you go in, and can't see your way out. You are in the town of Ouray." According to the *Mining Directory of San Miguel, Ouray, San Juan and La Plata Counties*, published by the County Directory Company in 1899, these were the directions to Ouray. (Denver Public Library, Western History Collection, #WHJ-1591.)

ON THE COVER. In 1923, Circle Route Stage passengers pose in front of John Donald's freighting establishment, located on the southwest corner of Second Avenue and Fifth Street. Donald serviced the stagecoach for this leg of the journey over the Million Dollar Highway, which was under construction. Donald advertised that "packing was a specialty." His livestock carried supplies to the mines, and his cutters took women on Sunday excursions. (Ouray County Historical Society Collection.)

IMAGES of America
OURAY

Gail Zanett Saunders, Maria Jones,
and the Ouray County Historical Society

Copyright © 2010 by Gail Zanett Saunders, Maria Jones,
 and the Ouray County Historical Society
ISBN 978-0-7385-8034-0

Published by Arcadia Publishing
Charleston, South Carolina

Printed in the United States of America

Library of Congress Control Number: 2009940083

For all general information contact Arcadia Publishing at:
Telephone 843-853-2070
Fax 843-853-0044
E-mail sales@arcadiapublishing.com
For customer service and orders:
Toll-Free 1-888-313-2665

Visit us on the Internet at www.arcadiapublishing.com

*Dedicated to the many volunteers, past and present,
of the Ouray County Historical Society*

Contents

Acknowledgments 6

Introduction 7

1. Many Miles, Many Mountains: Chief Ouray, Chipeta, and the Uncompahgre Utes 9
2. The Birth of a Mining Town 25
3. Of Mines, Mills, and Mining Camps 37
4. The Golden Age in a Victorian City 71
5. A New Century 87
6. Recreation and Celebration: Then and Now 103
7. Historic Research and Preservation 121

Selected Bibliography 127

Acknowledgments

We are grateful to the Board of the Ouray County Historical Society for collecting and preserving the photographic archive that documents the visual history of Ouray County and for granting us the permission to use it. Many have given photographs to the historical society, and we wish to acknowledge their contributions. It is impossible to list everyone who contributed to this book. We appreciate all the help and knowledge.

Doris Gregory's books and files were used as source material. Her efforts at preserving and compiling Ouray County's history are immeasurable. George Moore's volume *Mines, Mountain Roads, and Rocks* was the main source of information on mining. Special thanks go to Steve Baker, Rick Trujillo, Roland McCook, and Robert Stoufer for sharing their insights and expertise. We would like to thank Michael Canavan, Joan Fedel, Phil Icke, Cecilia Harvey, Elwood and Rosanna Gregory, Don Paulson, Chris Bonatti, Bud and Deb Kay, Carl Bates Jr., and Bud Zanett for sharing their photos and stories. Museum volunteers Glenda Moore, Don Paulson, Tom Hillhouse, and Walt Rule gave generously of their time and knowledge. We would also like to thank Maria Marcantonio for her help with scanning the photos. Thank you to Arcadia Publishing for bringing to light these collections of historical images that form our heritage.

From Gail Saunders: Many thanks to the people in my life who have offered friendship and support—Vicki Law, Michael Ruchhoeft, Marne Kirstatter, Susan Palmer, Ronnie and Michelle Peelo, Rhonda Hovendick, Chris Reece, Mary Anderson, Joby Saunders, and my husband, Joseph. It has been a pleasure to work on this volume with Maria Jones.

From Maria Jones: I thank the Divine Creator for the incomparable beauty of the "San Juans." I thank and honor my parents, Gaspare and Yolanda Comito, who brought me into a lineage of art and music, teaching me to see the Creator in all things. I thank my father-in-law, R. D. Jones, who brings the "Wild West" into artistic awareness. And I thank my beloved husband, Greg Jones, for his constant encouragement and unconditional love. It was a great joy and honor to work with Gail Saunders on this project.

Images that appear in this book are courtesy of the Ouray County Historical Society (OCHS), the Denver Public Library, Western History Department (DPL), the San Juan Historical Society (SJHS), and other public and private collections as noted.

Introduction

Sometime in the mid-1700s, an old Moache Ute travelled to Abiquiú, New Mexico. In a pouch, he carried a sample of virgin wire silver. A blacksmith named José Manuel Trujillo bought his sample and fashioned it into two rosaries and a crucifix. This tale was included in the diaries of explorer Juan María Antonio Rivera.

Spaniards settled in the province of New Mexico as early as 1600. New Spain considered today's Western Colorado as part of its unknown borderlands. In 1765, Governor Tomas Vélez Cachupín sent Rivera to explore the Río Del Tizon (the Colorado River) to see if other Europeans had settled into this unknown territory and to search for silver. Rivera's party was the first authorized expedition to the north. According to Steve Baker, archaeologist and ethnohistorian, Rivera made two journeys in 1765; on his first expedition, he took ore samples back to Santa Fe. His expeditions set out from Santa Fe and veered west of the mountains near present-day Dolores. He reached the confluence of the Uncompahgre and Gunnison Rivers near present-day Delta, and on his return trip, he travelled through the Uncompahgre Valley, never reaching the great river. Rivera was an emissary who pried open the door for prospectors and traders to travel into the Ute-speaking territories.

It was the Domínguez and Escalante expedition of 1776 that became the most well-known Spanish expedition into Southwestern Colorado. Their mission was to reach the Spanish colonies in California by an overland route and to investigate stories of bearded men living in Northwestern Utah. These Spaniards ventured north by way of the Chama River, then along the San Juan Mountains to the Dolores River and across Dallas Divide. Ute guides led them over Grand Mesa. From there, the expedition marched to the Gunnison and White Rivers and then westward into Utah. Severe winter weather forced them to return to Santa Fe without reaching California. Their journey covered 1700 miles. Legends of lost Spanish gold mines would later intrigue Anglo-American prospectors who ventured into the San Juan Mountains.

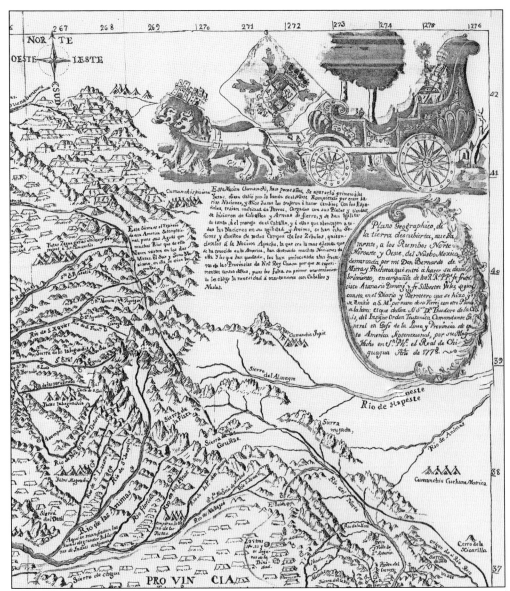

MIERA Y PACHECO MAP. Captain Miera accompanied the Domínguez-Escalante expedition of 1776. Drawn in 1778 for the king of Spain, Miera's map included the territory north of Santa Fe, and the image above is a section of that map. The padres found most of the rivers, streams, and mountains already named. In Father Escalante's diary, he wrote of crossing a river that the Yutas (Utes) called the Ancapagari (Uncompahgre River). Today's city of Ouray would be located in the mountain range called the Sierra de las Grullas. How the name changed to the San Juan Mountains will probably never be known. The journals, maps, and reports of this expedition greatly increased the Spaniard's knowledge of their northern frontiers. (Fray Angélico Chávez History Library, Palace of the Governors, Santa Fe, NM.)

One

MANY MILES, MANY MOUNTAINS

CHIEF OURAY, CHIPETA, AND THE UNCOMPAHGRE UTES

The Utes are part of a large language and cultural family called the Uto-Aztecan whose speakers extend from the Great Basin area to Central America. It is not known for sure when the Utes migrated into the mountains of southwestern Colorado. Archaeologists and ethnohistorians place the Utes in Colorado in the late prehistoric period. Ute rock art is one piece of evidence that tends to support their late arrival. The Utes in Colorado were generally divided into seven bands depending upon their geographical location. The Uncompahgre Utes occupied the Uncompahgre and Gunnison River drainages. Importantly, the Utes were never a unified people with a central authority. Utes called themselves "Nuche" or "the people."

By the 17th century, legal and illegal trade took place between the Spaniards and the Utes as they traded deer meat, hides, and slaves for corn and horses. By the early 19th century, some of these former Native American slaves lived a settled lifestyle around the communities of Abiquiu, Taos, and Santa Fe. These Genízaros had the Spanish surnames of their former masters, were baptized as Catholics, and were herders, ranchers, guides, and traders. Perhaps the Spaniards encouraged their settlement, as they provided a front line of contact between themselves and the Native Americans. Ouray, who would become the leader of the Uncompahgre Utes, was raised in Taos.

After the War with Mexico ended in 1848, the Americans moved quickly. Now the Utes were dealing politically with the U.S. government rather than Mexican authorities. American forts appeared on their frontiers. But it was the gold rush of 1859 that would forever change their lives. Miners considered the historically Ute lands to be public lands and moved into the San Juan Mountains as early as 1860.

The U.S. government established agencies to deal with the "Ute problem." They operated under a philosophy of a "peace plan." In essence, it was easier to feed the Native Americans than to fight them. The Utes would be taught how to become ranchers and farmers, and the U.S. government would use diplomats rather than the military to get the Utes to relinquish their territory, all in the spirit of Manifest Destiny.

AN ABUNDANCE OF WILDLIFE. Ute men hunted a variety of wild game. Arrow points were chipped from jasper, obsidian, or feldspar from well-known quarries. Ute men twisted sinew and used it for bowstring. Women did the meat preparation. Salt was a common preservative. The Paradox Valley or the La Sal ("salt") Mountains were common collection areas. (DPL, #C-130.)

THE HORSE. The acquisition of the horse from the Spaniards in the 1600s changed the everyday life of the Utes, but many were still walking even into the late 18th century. The tribes now hunted buffalo on the plains, became raiders, and traded more frequently with the Spaniards. Expert horsemen, they guided their horses with their knees, which freed up their hands. This 1890 photograph was taken on the Los Piños River on the Ute Reservation. (DPL, #P-51.)

OURAY: THE EARLY YEARS. Ouray (left) was born in 1833 in Abiquiu; his father, Guera, had a Spanish surname, Salvadore. Around 1843, Ouray's parents took him and his brother Quenche to a hacienda in Taos. They worked as servants. As was the tradition, they were able to leave the hacienda at the age of 17 or 18. Quenche stayed in Taos but Ouray moved back to Abiquiu. It was a time of unrest as fur traders, explorers, and miners arrived in Ute territory. Ouray's father became a Ute leader and Ouray followed him to western Colorado. A natural leader, aggressive, and a warrior, Ouray's abilities soon became apparent. At his father's death in 1850, he assumed the role of leader in his band. This drawing is the first-known image of Ouray. It is titled *Yulé* [Ouray] *et Quincy* [Quenche], *chefs des Yutes (bande des Sabquatches)- dessin de Janet Lange d'après une photograhie.* The picture appeared in an 1868 publication, *Le tour du Monde.* (DPL, #X-30707.)

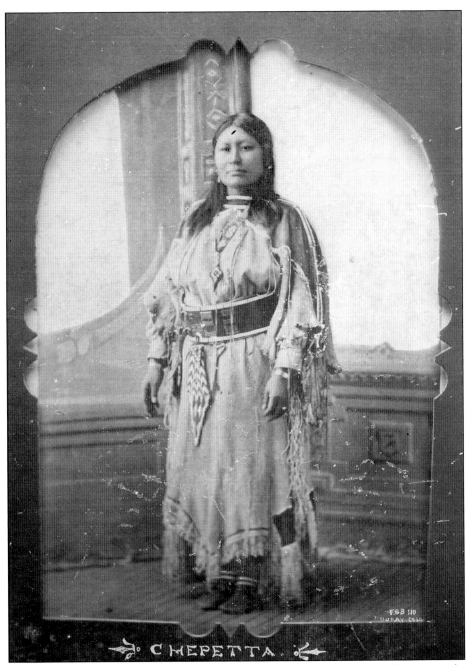

CHIPETA. Chipeta, whose name was misspelled here by the photographer, met Ouray, a widower, when she became the caretaker of his young son, Peron. At the age of 16, she married Ouray; he was 26. Her name is believed to mean "white singing bird." The Sioux raided one of Ouray's hunting camps and captured Peron. Chipeta never had any children of her own but raised and adopted many. This 1880 photograph shows Chipeta wearing a dress made of deer hides. Her wide belt is trimmed with beads and metal studs. Clothing with beadwork was usually worn for special occasions. (OCHS.)

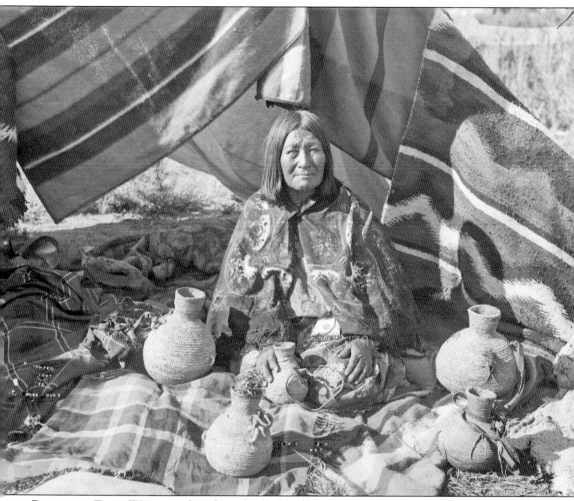

GATHERING FOOD. Women gathered nearly all the edible plants of their territory including nuts, seeds, wild potatoes, sunflowers, roots, and berries. Piñon nuts were a valued food source. They obtained corn from the Pueblo peoples and informally planted their seeds in river bottoms. Traditionally, the women prepared the food and created coiled baskets and simple yellow-brownish- or gray-colored pottery shaped into wide-mouthed jars. Rawhide bags were used to store and carry food. They ground seeds on stone mutates with manos to make flatbreads or mush. Foodstuffs were dried for later use. The women used native plants and herbs for medicinal remedies. Women's traditional roles included child-rearing and preserving oral traditions. They also tanned and made clothing. Shown this picture of Chipeta (Ouray's wife) are round-bottomed, narrow-necked, coiled baskets coated with pitch to make them waterproof. (DPL, #Z-1466.)

DWELLINGS. A nomadic people, the Utes never lived in permanent dwellings like their Pueblo neighbors to the south. They lived in conical brush houses or wickiups often fashioned of juniper or piñon branches. Later, teepees were also used as shelter. Made of hide-covered poles, dogs and later horses transported teepees with travois. Many preferred the cooler wickiups during the summer. In the winter, sites were near springs or streams that had protection from the weather. In the summertime, they moved to the higher mountains and used aspen, spruce, and fir for housing materials and firewood. They had favorite areas that they returned to season after season. The Utes had a connection to their environment and a complex relationship with the natural world. Many mountains were considered sacred. Doorways faced to the east, the direction of the sunrise. (Museum of Western Colorado.)

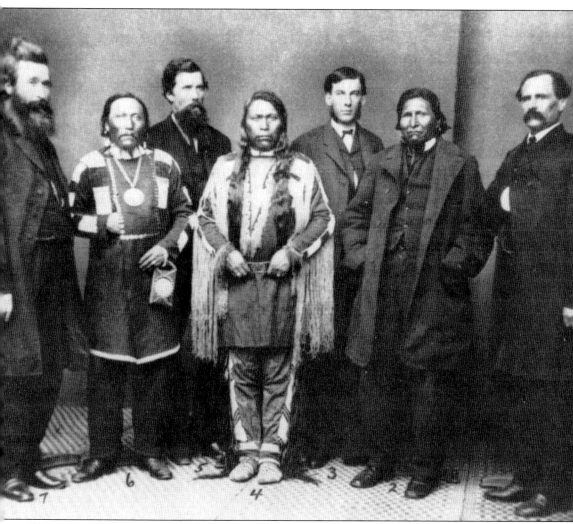

Treaty of 1868. Serving as interpreter, Ouray (center) went to Washington with the Ute delegation. Sightseeing tours, ostensibly to show the Utes the power of the federal government, were arranged. Ouray clearly understood the intention. This treaty moved the Utes into the Western Slope of Colorado and established two agencies, the White River Agency and the Los Piños Agency near present-day Saguache, which served the Uncompahgre Utes. The U.S. government appointed Ouray as Chief of the Consolidated Ute tribes, but Ouray was never accepted as a representative leader by all the Ute bands. (Museum of Western Colorado.)

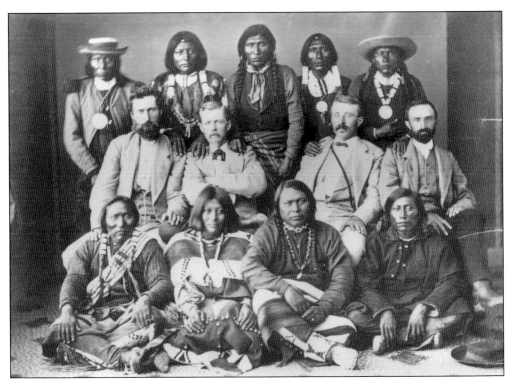

BRUNOT AGREEMENT OF 1873. By the early 1870s, rumors of gold brought prospectors illegally into the Ute reservation. Ouray did not wish to sell any more Ute lands, but the miners' opposition included a willingness to use firepower if they were forced off their claims. Felix Brunot, president of the U.S. Board of Indian Affairs, and Otto Mears, who acted as interpreter, helped finalize this treaty. The Ute people ceded 3,450,000 acres in the mineralized San Juans to the U.S. government while retaining the Western Slope valleys. A large portion of the tribe considered Ouray more the white man's friend than theirs. Several threats were made on his life. After the signing of the treaty, thousands more miners and settlers rushed into the region. In this 1873 delegation to Washington, Ouray and Chipeta are in the center of the front row; Otto Mears is on the far right in the second row. (DPL, #X-30679.)

SECOND LOS PIÑOS AGENCY. By 1875, the agency near Saguache was moved to a new site near present-day Colona. Settled in 1876, the rapidly growing town of Ouray, named after Chief Ouray, put pressure on the deer and elk populations. Sometimes starving and not permitted to hunt, the Utes had no choice but to accept agency rations. The Los Piños Post Office was established on February 23, 1877. Seated is Otto Mears. (OCHS.)

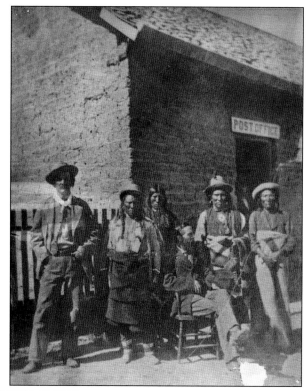

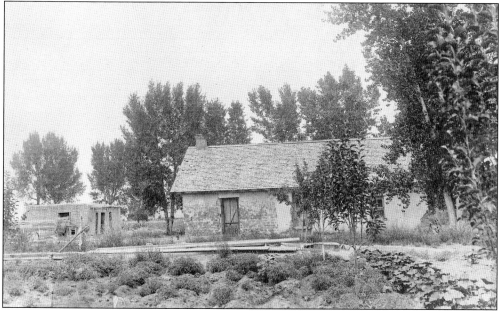

OURAY'S FARM. Ouray built an adobe home on his farm located about 9 miles north of the agency. The property included about 100 acres of bottom land, housing for Mexican laborers, and several outbuildings used for storage and corrals. Ouray had a corral and a carriage given to him by Colorado governor McCook. Chipeta played the guitar and sang for their frequent guests. This view was taken after the home had been abandoned. (OCHS.)

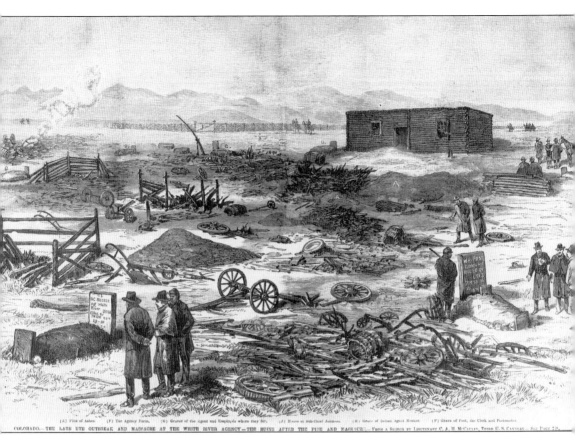

COLORADO.—THE LATE UTE OUTBREAK AND MASSACRE AT THE WHITE RIVER AGENCY—THE RUINS AFTER THE FIRE AND MASSACRE.—From a Sketch by Lieutenant C. A. H. McCauley, Third U. S. Cavalry.—See Page 72.

MEEKER AFFAIR. Dogmatic but well-meaning, Nathan Meeker was appointed as agent to the White River Utes. With reformer's fury, he set out to turn "his" Utes into Christian farmers. Then Meeker decided to plow the Utes' horse racing track. It would make a good field, he reasoned. After Ute leader Johnson instigated a fight, a frightened Meeker called for troops. The Utes were adamant that the soldiers, led by Maj. T. T. Thornburg, not come onto their reservation. Shots were fired and arrows volleyed. Meeker's wife, daughter, and Flora Ellen Price, a white woman living on the reservation, were taken as captives. Ouray appealed to the Utes to cease fighting. The result was 13 soldiers killed and 43 wounded and 37 Utes killed. The women and children were brought to Chipeta's home, where she cared for them. (DPL, #X-30699.)

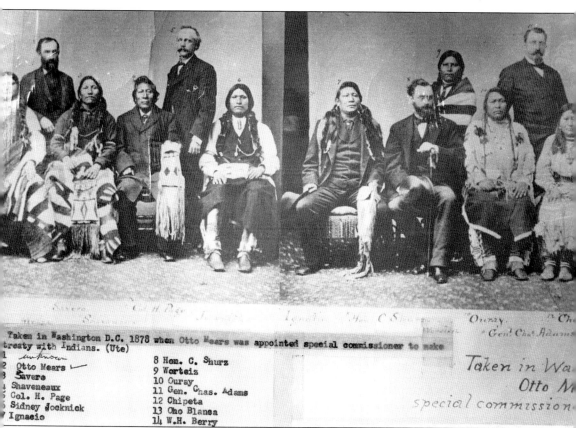

Taken in Washington D.C. 1878 when Otto Mears was appointed special commissioner to make treaty with Indians. (Ute)

1 unknown
2 Otto Mears
3 Savero
4 Shaveneaux
5 Col. H. Page
6 Sidney Jocknick
7 Ignacio
8 Hon. C. Shurz
9 Worteiz
10 Ouray
11 Gen. Chas. Adams
12 Chipeta
13 Oho Blanca
14 W.H. Berry

"THE UTES MUST GO." This rousing headline appeared on October 25, 1879, in the *Ouray Times*. The sentiment was echoed by other newspapers in the state. It did not matter that the Uncompahgre Utes were not participants in the Meeker Affair. Governor Pitkin, who had obtained much wealth from the mines around the town of Ouray, called for the Utes' removal. Ouray County's militia, Companies D and E, mustered out. Rumors flew. The Ute chiefs once again traveled to Washington, hoping to get fair treatment, and on March 6, 1880, the Agreement of 1880 was signed. It provided for the removal of all the Ute bands to permanent reservations. Ouray realized his options: fight or be removed. If the land at the junction of the Grand (Colorado) and Gunnison Rivers was suitable for agriculture, the reservation for the Uncompahgre Utes would be located there. The White River Utes were to be relocated to a reservation in Utah. For the treaty to be binding, three-quarters of the Ute men were required to sign it. In this photograph, Otto Mears is second from the left. Sixth from the right is Chief Ignacio of the Southern Utes. Chipeta and Ouray are seated on the far right. Chief Ignacio had concerns that the terms of the agreement would be followed. Furthermore, Ignacio wanted to make sure that the Southern Utes' reservation's boundaries in the southwestern section of the state were properly marked. (OCHS).

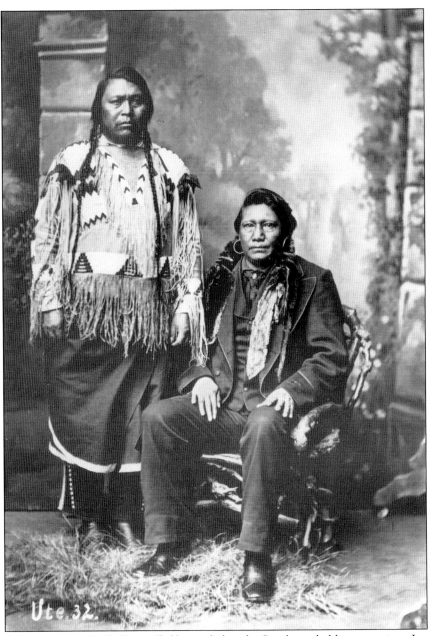

OURAY'S DEATH. Gravely ill, Ouray (left) traveled to the South, probably to convince Ignacio to influence the Southern Utes to sign the agreement. Physicians, both Ute and white, were called in, but Ouray died in August 1880. He was buried in an unmarked rock crevice, following Ute custom. Upon hearing of Ouray's death, Judge Story presided over a commission at the Ouray County Courthouse. The resolution read in part: "Resolved: That it is with the deepest regret that we have heard of the death of the Chief of the Confederated Utes in honor of whom this town and county were named. Resolved: That all the citizens of this state and the U.S. Government have lost a steadfast friend and benefactor" This photograph of Ouray shown with Ignacio was taken shortly before Ouray's death. The Uncompahgre Utes lost their chief diplomat and spokesman. (DPL, #X-30601.)

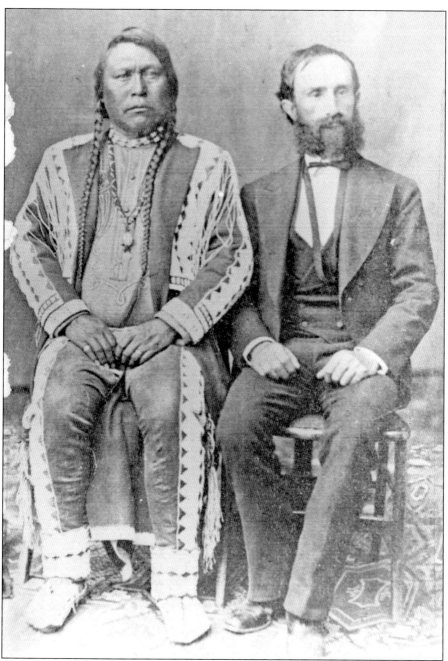

UTE REMOVAL. Otto Mears had accompanied Ouray to Washington, profited from his business dealings with the Los Piños Agency, and acted as Ouray's advisor. After Ouray's death, Mears gave $2 to each Ute who agreed to sign the Agreement of 1880. Then he deemed the land at the confluence of the Gunnison and Colorado as unsuitable for farming. Today the city of Grand Junction is located on this site. General MacKenzie, with four companies of cavalry, moved 1,458 Uncompahgre and White River Utes by gunpoint to a reservation 140 miles east of Salt Lake City. Within a few months, nearly all the lands of the Uncompahgre Utes were occupied by white settlers. The Southern Utes remained on a reservation in southwest Colorado. (OCHS.)

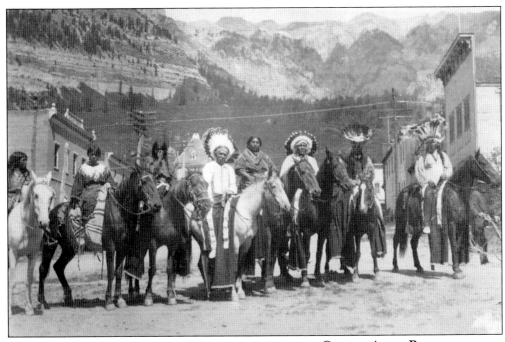

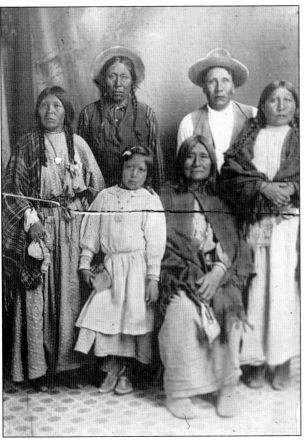

CHIPETA AFTER RELOCATION. Not knowing the edible plants and herbs in the eastern Utah desert, Chipeta was at a loss in the new lands on the reservation. She returned to a nomadic life, living in a teepee and raising sheep and goats with the help of her family. By the turn of the century, Chipeta was traveling about western Colorado as a celebrity, often riding in parades as an honored guest. She visited the hot springs near Ridgway several times. Judge William Rathmell was secretary of the Ouray Commerce Club when Chipeta and a group of Utes visited town on July 6, 1911. Chipeta and her entourage were guests at the Beaumont Hotel, were entertained with band music, and were taken to a picture show. Rathmell (above, second from right) was made an honorary chief. In his studio in Montrose, Thomas McKee took a photograph of Chipeta and other travelling Utes. (Above, OCHS; left, Ruth and Marvin Gregory collection.)

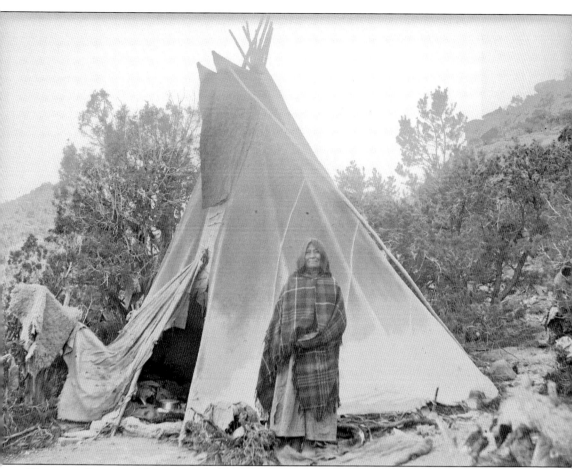

DEATH OF CHIPETA. About a year before Chipeta died, Thomas McKee took this photograph of her in front of her teepee in Utah. On the back of the photograph, he wrote that the piece of rawhide at her feet was being "softened" for use as moccasins; she was barefoot. Almost totally blind, Chipeta suffered from gastritis. In August of 1924, Chipeta was buried in a simple grave at Bitter Creek. On March 10, 1925, she was reburied at a site just south of Montrose near her old farm, which is now part of the Colorado Historical Society's Ute Indian Museum. Thousands of people attended her funeral. Her brother McCook, standing to the left of her casket, reportedly said, "Chipeta, I have brought you home." McCook himself passed away in 1937 and is buried beside Chipeta. (DPL, # Z-1363.)

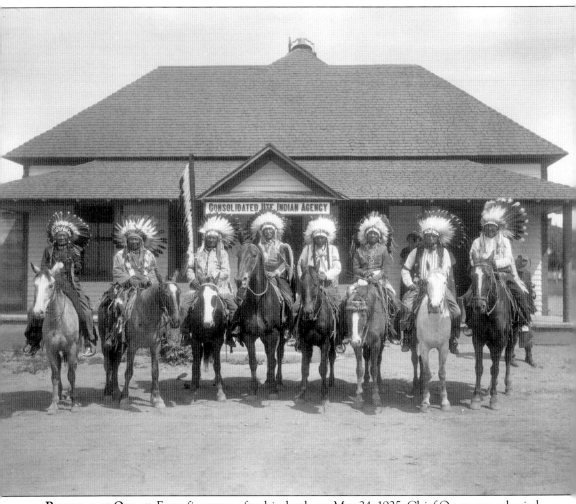

REBURIAL OF OURAY. Forty-five years after his death, on May 24, 1925, Chief Ouray was reburied at Ignacio. The reburial was supervised by the same chiefs who had originally placed him in his grave. From left to right are George Norris, also known as Naneese; McCook; Joseph Price; and Buckskin Charlie. The last four are unidentified. They are shown in front of the Consolidated Ute Agency building in Ignacio, Colorado. The men vouched for the fact that the bones they interred were indeed those of Ouray. (DPL, #GB-7914.)

Two

The Birth of a Mining Town

In 1975, Jack Pierson found a 100-year-old diary in the walls of an old bunkhouse near Olathe, Colorado. The diary was penned by George Howard, a fifty-niner and a Baker's Park (Silverton) pioneer. His journal chronicled his 1872 prospecting journey. He mentioned in his diary that he made his first trip to the Ouray area in 1860 when he was around 20 years old. A June 1913 article in the *Ouray Plaindealer* documented his 1860s trip. The headlines read, "This Man Saw Ouray in Summer of '60.'" He told the reporter that a "jungle" of scrub trees filled the basin, deer and elk were plentiful, and he did not see any Utes.

Ouray's first permanent settlers came from the south, as the Ute reservation lay to the north. In 1875, Augustus Begole and his companion Jack Eckles prospected in the little park that Howard had seen 15 years before. What they saw looked promising, and they made their way back to Silverton for supplies. When they returned later that fall, several more prospectors accompanied them. This core group of men, including R. F. Long, E. W. McIntyre, A. J. Staley, and Capt. Milton Cline, set about to stake claims, to mine, and to found a new town.

Ouray was incorporated by the San Juan County Board of Commissioners on September 13, 1876. First called Uncompahgre, the town was properly laid out on a grid pattern with a wide Main Street that would allow freight wagons the room to turn around. Fire was a constant threat to mining camps, and the wide street would also help prevent a fire from crossing from one side of the street to the other. Chief Ouray often visited the new settlement from the Ute Agency, and the town fathers changed the name of their new settlement to Ouray in the chief's honor.

Isolation made the first years difficult. Food was scarce that harsh winter of 1877. Even so, the town was booming, and a city of tents and crude log cabins sprang up. Ouray was fortunate to have had founders with foresight and business experience who understood the necessity of legally establishing a new community.

George Howard. From Elizabethtown in New Mexico, Howard prospected north into the San Juans looking for his El Dorado. He left his prospecting life to become a Civil War soldier, but the mountains called him back. He traveled with five burros and one pony. He carried a double-barreled shotgun, a Winchester rifle, a six-shooter, and six months of supplies. Howardsville, the ghost town near Silverton, was named for him (SJHS.)

Augustus Begole. A Silverton pioneer, Begole was a self-proclaimed "Indian fighter." He suffered with old arrow wounds. He hit pay dirt with his partner, Jack Eckles, after locating a rich set of parallel veins while prospecting up Canyon Creek. They named their find Mineral Farms and sold the mine for $125,000. Begole took his share and opened up a grocery store on Ouray's Main Street. (OCHS.)

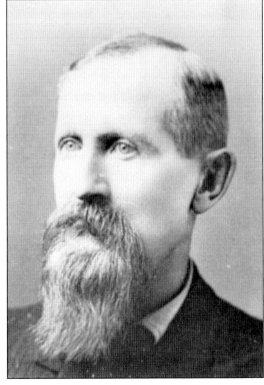

DAVID FRAKES DAY. The outspoken, obstinate, partial, articulate Day moved to Ouray in 1879. He brought his printing press from Lake City and proceeded to start his newspaper, the *Solid Muldoon*. The paper was firmly on the Democratic Party's side. His exposés and sense of humor made it one of the most popular papers in the West, but proper young women were not allowed to read it. He moved his paper to Durango in 1892. (OCHS.)

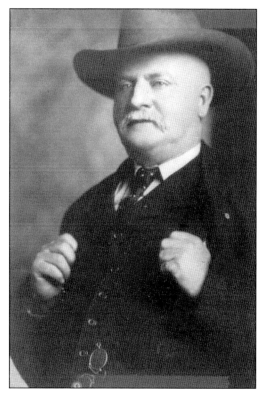

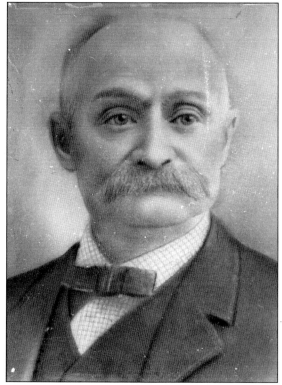

CAPTAIN CLINE. Milton Cline was the town's first postmaster and mayor. He supervised the plotting of the new community and filed for the town's incorporation. For her various good deeds, Cline's wife Elizabeth earned the nickname "Mother Cline." The couple left the mining camp a few years later for the ranching life and settled in Cimarron. (OCHS.)

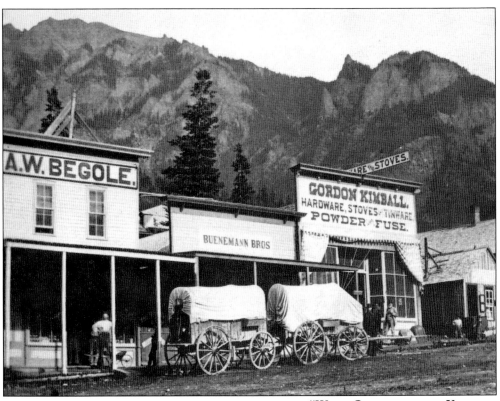

"WHEN OURAY WAS VERY YOUNG AND RATHER WILD AND WOOLY, 1881." This headline appeared in the January 27, 1905 *Plaindealer*. In the above image, from left to right, Dave Frakes, Gus Begole, and M. W. Dresser stand on the boardwalk. The mule skinner, Chambers, watched the lead mule in order to prevent the animal from skittering when the camera went off. The article reported that the men took a few "smiles" from a jug in the freight wagon. (DPL, #X-12814.)

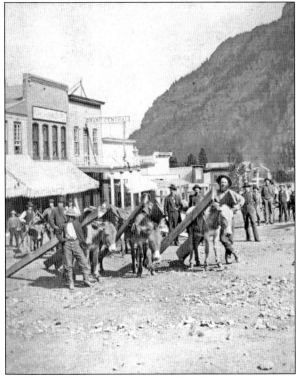

EARLY MORNING PACK TRAIN. A familiar early morning scene, a burro train packed with lumber stops for a picture before heading to the mines. Seen in the background here, the Grand Central Hotel burned around 1885. (OCHS.)

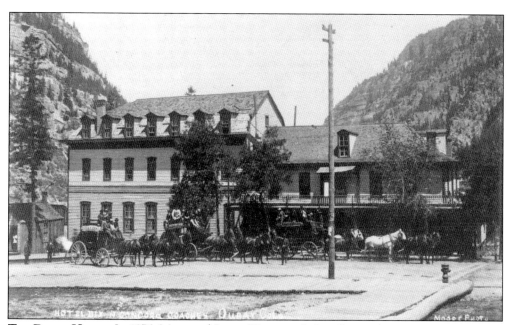

THE DIXON HOTEL. In 1876, Mary and James Dixon settled in Ouray. An enterprising woman, Mary opened a boardinghouse in her cabin. She kept the floors clean, cooked appetizing meals, and her business was swift. Encouraged, Mary took out a loan to enlarge her cabin to a two-story hotel. In 1881, she was unable to repay her loan, and her hotel was auctioned to the highest bidder. The frame structure burned in 1892. (OCHS.)

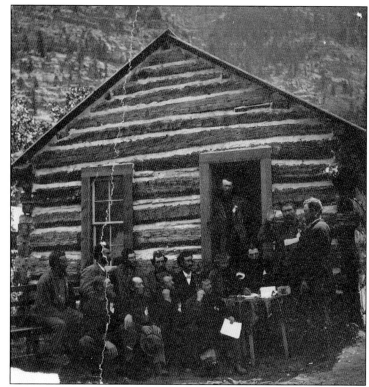

FIRST GRAND JURY. The court system, with its layers of lawyers and judges, was established early in mining camps. In 1876, a grand jury convened to investigate the death of Edward Jamison, who died in his tent on November 18. As reported by Ann Hoffman in *Ouray's Historic Main Street Early Visions Wild Times*, "It was then determined by the grand jury on November 20, 1876, that Jamison died of a self-administered overdose of oil of almond, reason, unknown." (OCHS.)

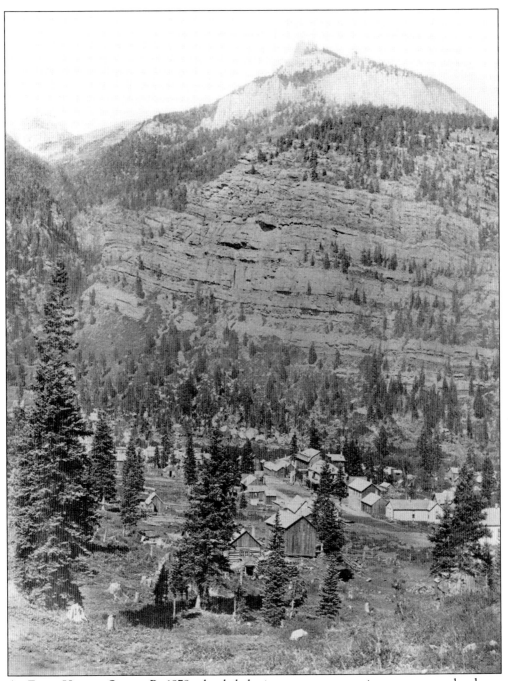

AN EARLY VIEW OF OURAY. By 1878, a bank, bakeries, grocery stores, nine carpenters, a hardware store, two hotels, four mining engineers, two insurance agents, lumber dealers, and the inevitable saloons had set up shop. In this photograph taken from the east in the early 1880s, stumps from the trees that once covered the park are still visible. The two-story structure with dormer windows was the Dixon House. Blythe Hall, the two-story structure near the Dixon Hotel, housed the city hall and courthouse. By 1880, the census reported 864 permanent residents. The town had regular mail service. (OCHS.)

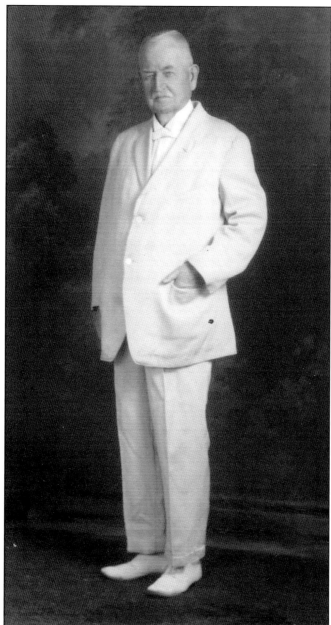

Dr. William W. Rowan. The colorful Dr. Rowan wore his all-white suit, including shoes, socks, and hat, for special occasions. For parades, he rode a white horse. In 1879, Dr. Rowan was practicing as a surgeon at Fort Crawford when he resigned from that position and moved to Ouray in 1880 to open a medical practice. A civic-minded, popular resident, Rowan was a founding member of the Ouray County Democratic Party. He served as mayor for six terms and was elected to the Colorado State Legislature. But his involvement with the community did not stop there; he was superintendant of schools and served as the first exalted ruler of the Ouray Elks Lodge. He was an active member of nearly every other lodge in town. He served Ouray as physician until his death in 1926. Dr. Rowan often joked that his community was healthy, "distressingly so." (Southward collection.)

JESSE BENTON, LAWMAN. When towns needed "cleaning up," Benton applied for the job. His reputation spread after he worked in Rosita, Colorado, where he shot and jailed some gunmen. When the newly formed town council put out the word that they needed some help with lawlessness, Jesse answered. He came to Ouray in 1876 and served as both town marshal and later sheriff. Jesse reportedly killed six men, all in self-defense. When Governor Pitkin called up the militia in 1879 because the White River Utes were "on the warpath," Jesse mustered out Companies D and E, the Ouray sharpshooters, which he had formed two years earlier. When Jesse married Elton Ramsay in 1886, she was 24 to his 54. The newspaper report of his wedding read, "The groom Jesse Benton is well-known throughout Colorado and New Mexico as one among the bravest and truest men." (OCHS.)

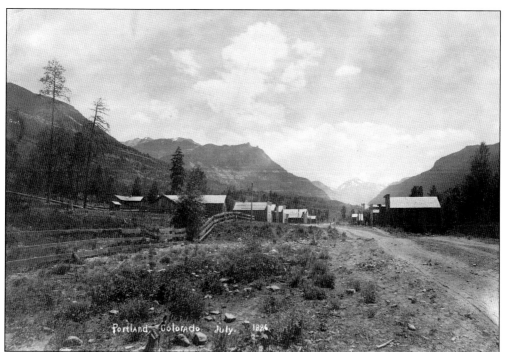

ENOS HOTCHKISS AND THE TOWN OF PORTLAND. Otto Mears hired Enos Hotchkiss to build the Lake City–to–Saguache Toll Road. Like other mining camp residents, he gambled in mining on the side and started the Golden Fleece Mine, a lucrative strike. In 1877, with his brother Preston, Enos started the town of Portland, located a short distance north of Ouray, where the valley widened and where farming was possible. The brothers owned a store there and, in the late 1870s, sold produce to the miners, for which they were well paid. The town site was located just a few miles south of the Ute reservation. Portland survived for about 10 years until it was abandoned when bypassed by the railroad. Enos later moved to the North Fork Valley and founded the town of Hotchkiss. At right, students line up for a photograph in front of the Portland School. (Above, SJHS; right, OCHS.)

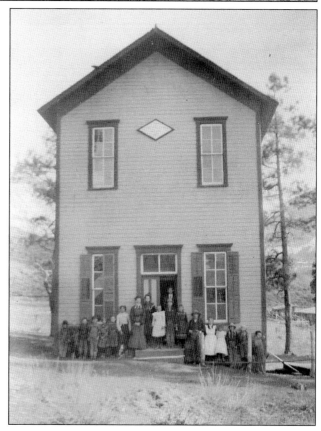

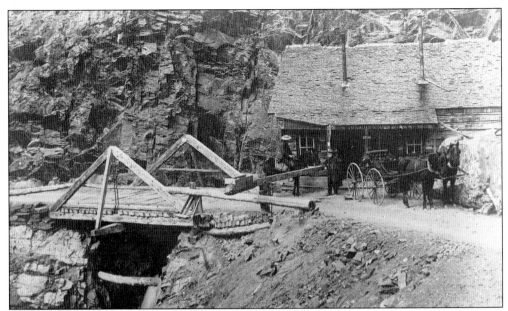

OTTO MEARS TOLL ROAD. Nicknamed the "Pathfinder of the San Juans, Mears was not trained in engineering. He constructed over 450 miles of toll roads, including three into the town of Ouray. Mears operated several mines, opened stores, and built three railroads in the San Juans. In 1883, Mears contracted with the city of Ouray to build a toll road south through the rugged Uncompahgre Canyon. His most impressive project to date, he carved a 12-mile road out of solid rock, reaching the Red Mountain region where rich silver deposits had been located. His tollgate was placed over the narrow section of road at Bear Creek Falls. A gatekeeper lived in the small cabin, and he lifted the gate after the toll was paid. The toll fee was $5 for a team and $2 for a saddle horse. The gatekeeper also served as the town gossip, spreading news in two directions. Today Mears's toll road is the first section of the Million Dollar Highway, which leads to Silverton. (Above, OCHS; below, USGS.)

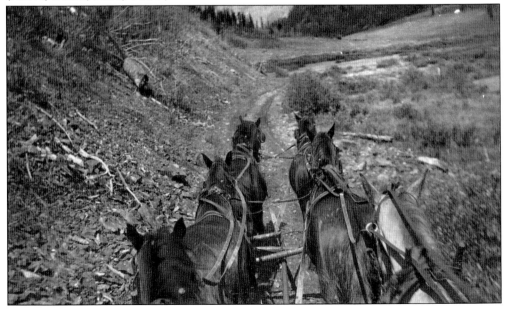

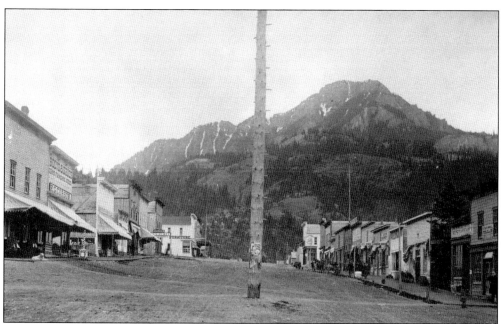

CITY FLAGPOLE AROUND 1885. Located at the intersection of Main Street and Sixth Avenue, the flagpole was at the epicenter of the city's activities. The flagpole remained standing until the next century, when automobiles arrived, and it became a hazard. Mount Hayden stands in the distance. (OCHS.)

KIMBALL HARDWARE. Gordon Kimball was first employed by Otto Mears to manage his hardware store. Like other merchants, he tinkered in mining in his spare time. Four years later, he purchased the store from Mears and renamed it Kimball and Company. (OCHS.)

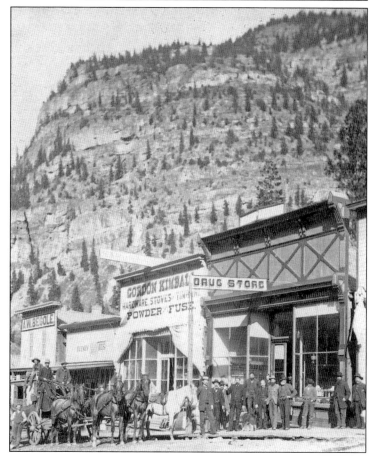

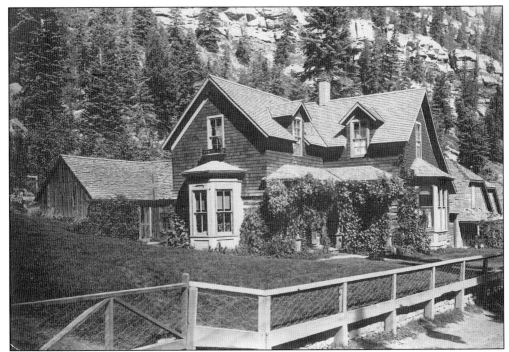

WHEELER HOUSE AROUND 1880. The Wheeler family prominently contributed to the history of Ouray as well as southwest Colorado. Lt. Maj. George Montague Wheeler led the Wheeler Geographical Survey. Wheeler's eldest brother, Maj. W. D. Wheeler, was appointed agent at the Los Piños Indian Agency near Colona, and their brother Charles August Wheeler, surveyor and banker, settled in Ouray in 1877 and moved into this home on Oak Street. (SJHS.)

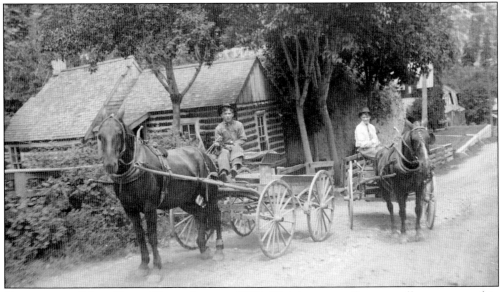

CHARLES AND MARY RYDER HOME AROUND 1881. This home was first a small one-room cabin built by the Ryder family. When John Rice, later owner of Rice Lumber, moved to Ouray, he rented the home from the Ryder family for a few years. The home has been remodeled several times but is still standing at 546 Oak Street. (OCHS.)

Three

OF MINES, MILLS, AND MINING CAMPS

The complex and rugged geology of the San Juan Mountains formed one of the most highly mineralized regions of the country.

The mines in Ouray County are generally grouped into three districts. The Uncompahgre district encompasses the mines north of Ouray and includes the successful Bachelor, American Nettie, and Calliope Mines. Ouray was the supply center for this district.

In 1881, rich silver deposits were discovered in the Red Mountain district about 12 miles south of Ouray. The Robinson, Yankee Girl, and Guston Mines pumped out millions of dollars of ore. Almost overnight, five settlements crowded around these mines, including Ironton, Red Mountain Town, Red Mountain City, Guston, and Congress. The deeper the miners dug, the more water flooded into their shafts, and the acidic water corroded machinery. After the Silver Panic of 1893, the mines began to close.

The Mount Sneffels district wound up Canyon Creek to Yankee Boy Basin. The Revenue and the Camp Bird Mines produced millions and contained some of the most long-lived and profitable mines in the region.

Fire, rockslides, and avalanches made working and living at these high elevations dangerous. Ore shipments and supplies had to be packed over steep and narrow mountain roads on the back of a mule or burro or by six- or eight-horse wagon teams.

Mining moguls like Tom Walsh and A. E. Reynolds made immense wealth from the earth, but the story of Ouray's mining districts was also the story of the ordinary miner who faced hardships and carried dreams that were never quite realized. Nonetheless, many found that mining was a profession that could seep into a man's veins.

For a century, mining provided the backbone of Ouray County's economy. Over 175 mines operated, and thousands of claims crisscrossed the mountainsides. And even more money came from selling mining company stock than from ore shipped.

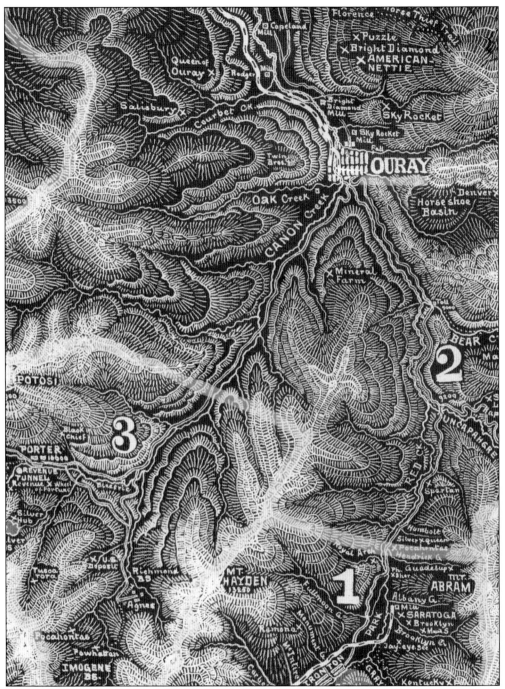

FISCHER MAP. This rare 1891 map of the mining districts of the San Juan Mountains was drawn according to an act of the U.S. Congress, and Emil B. Fischer compiled and drew the map for the Library of Congress. (OCHS.)

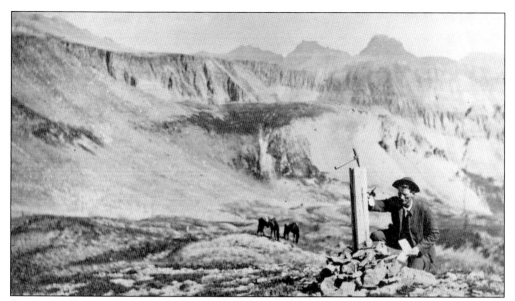

STAKING A CLAIM. To obtain the legal rights to a possible body of ore, the prospector first had to "claim" it. When he located an outcrop, he marked the rectangular corners of his 300-by-100-foot claim, usually with rock monuments. Then, in the center of his claim, he placed a larger monument. On a scrap of paper, he recorded his name, the date, and any other identifying information. From this point, he had 30 days to log his claim with the recorder in the nearest mining district. This photograph was taken in the upper Imogene Basin. (OCHS.)

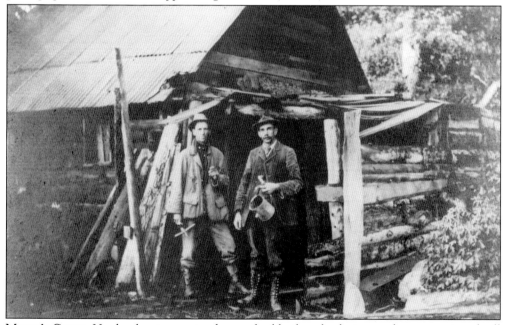

MINER'S CABIN. Hardrock miners mined ores of gold, silver, lead, zinc, and copper, minerals all found in the San Juan Mountains. The man on the right carried his candle; early miners used candles for underground illumination. According to the note on the photograph, the man with the necktie "has that out-of-town look." The unknown writer concluded, "He must be a visiting back east mining magnate or a Harvard-type geologist." (OCHS.)

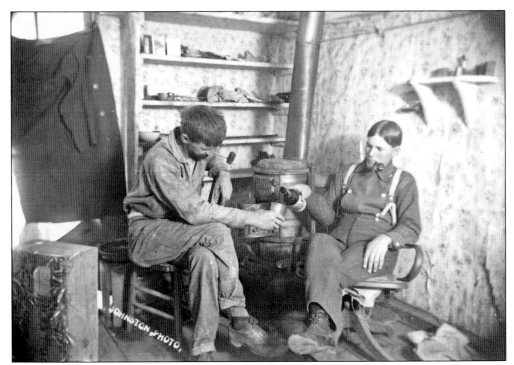

SHARING A BOTTLE. In their off hours, these miners sit back to share a bottle and smoke a pipe. Ore samples rest on a shelf. Many miners died of alcoholism. The main commodity shipped into mining camps was alcohol. (OCHS.)

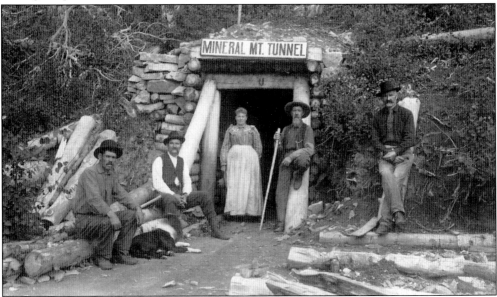

MINERAL MOUNTAIN MINE. After World War I, mining went corporate. But in this undated photograph, four men and a woman stand in front of a small adit named the Mineral Mountains Tunnel. If an independent crew did not find a rich vein, they could always go to work for a mining company. The pay was good, from two-to-five-times better than an agricultural or industrial worker earned. (OCHS.)

SORTING AND SACKING. Working for a small, independent operation meant that miners had to focus on only the most profitable ore, sorting and hand-sacking the higher-paying, high-grade ore. In this winter scene, these men separate ore-bearing rock from waste rock. Sacks of ore would then be shipped to a custom mill for processing. The arrival of the railroad enabled miners to ship lower-grade ore, as freight costs were less. (OCHS.)

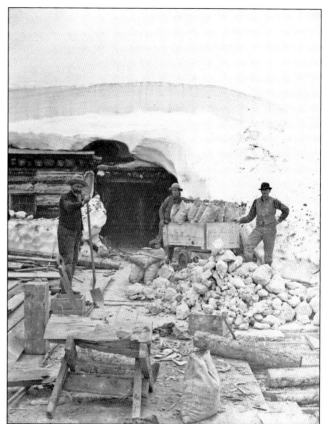

BACHELOR'S HOME. This unidentified group of miners stood in front of a cabin, which they apparently shared. Without wives or sweethearts nearby, companionship came from the men you mined with. It could take a half a day or more to get to town. Dressed in their best clothes, these miners were celebrating the Fourth of July in 1909. (OCHS.)

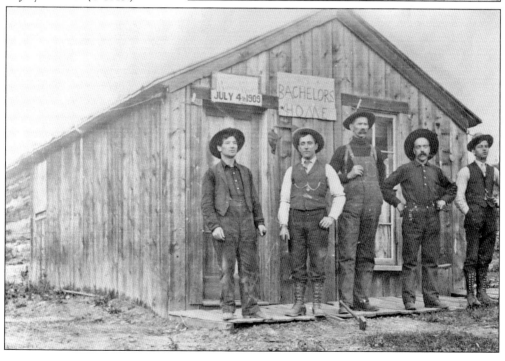

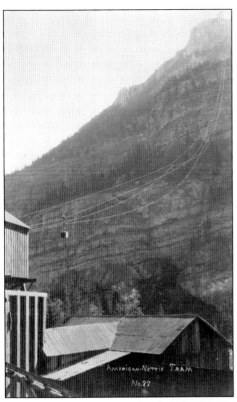

AMERICAN NETTIE MILL AND MINE. Located north of Ouray, the Nettie was a gold producer in the 1890s. A gravity-operated aerial tram connected the mill on the west side of the river to the mine on the east side. The unsupported span ran 1800 feet across the valley. The Nettie was a dry mine, which meant that the miners inhaled dust day after day; consequently, often a miner's life might last just 40 years. By this time, electricity (not candles) provided light. (OCHS.)

WANAKAH PORTAL. In this view, the Wanakah miners gather around the mine's portal. Hilda V. Forsman, cook, leans against the cribbing wall. Located just south of the American Nettie Mine, the Wanakah, like the Nettie, is in sedimentary sandstones on shales. (OCHS.)

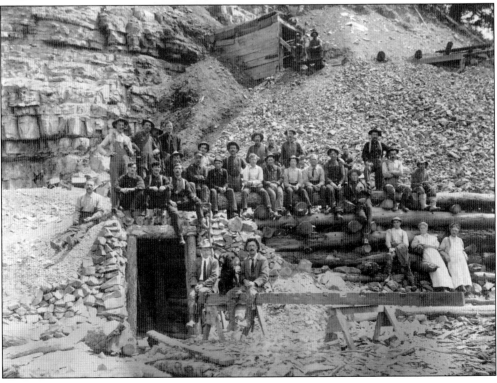

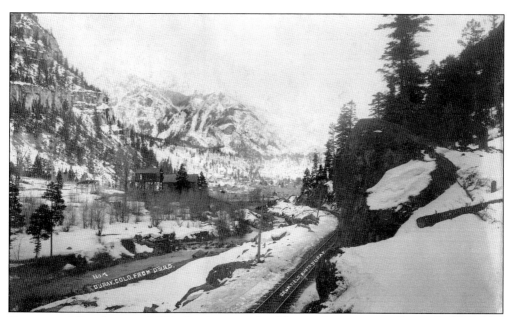

SKYROCKET MILL AROUND 1890. On the east side of the north entrance to Ouray, the Skyrocket Mill, serving the Skyrocket and Speedwell Mines, sat near the railroad tracks. To facilitate the shipping of ore, a row of mills lined the tracks north of town. The people in Ouray could hear the thud of stamp mills as the sound reverberated for miles. (OCHS.)

GOLD CROWN MINE AND MILLING COMPANY. Mills were often built before the geologists determined that enough ore was available to make the operation successful. Two brothers from New York, W. F. and E. C. Mattes, built their mill beside the railroad tracks north of town, but it was never profitable. In the early 1920s, Frank Henn and his partners rebuilt the mill with the intention of doing custom milling for mines still operating in the region, but it burned in June of 1921. (OCHS.)

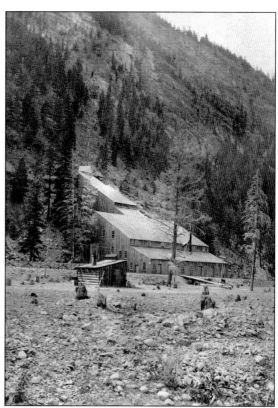

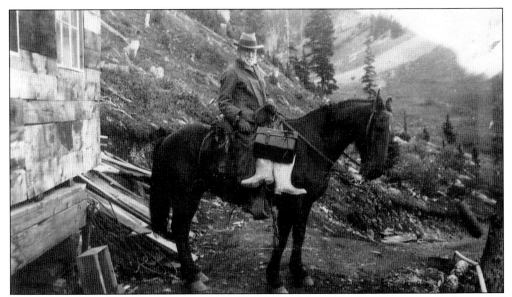

GEORGE HURLBURT. A surveyor by trade, Hurlburt platted many San Juan town sites and surveyed mining claims. The Red Canyon section north of Ouray intrigued Hurlburt. Together with two other bachelors, C. A. Armstrong and Frank Sanders, he started the successful Bachelor Mine in the early 1890s. With his profits, he invested in the Bank of Ouray. He did not remain a bachelor for long; he married teacher Cora Hickman in 1894. (Southward collection.)

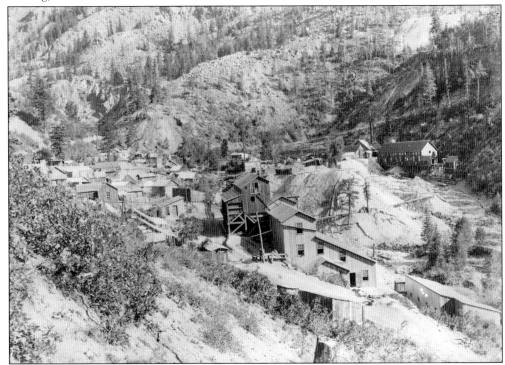

ASH. The Bachelor town site located on Dexter Creek was named Ash, an acronym for Armstrong, Sanders, and Hurlburt. In 1899, the town's post office and school served the community, which once numbered 200. (DPL, #X-5645.)

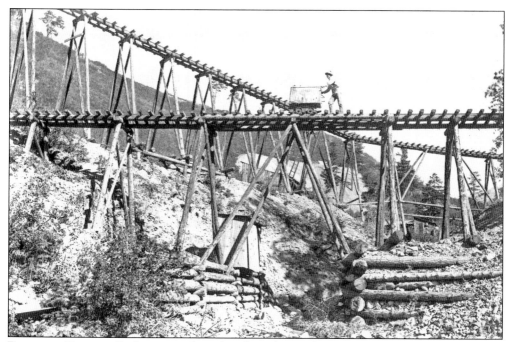

BACHELOR TRESTLE. Rails on top of trestles allowed ore to be transported from the mine to the mill. Men climbed up on the trestle by ladder and pushed the ore cars as they moved downward towards the mill. (OCHS.)

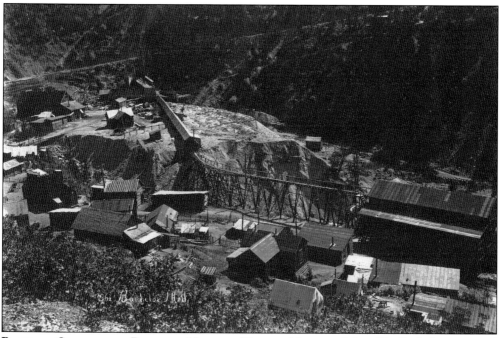

BACHELOR COMPLEX, THE BACHELOR MINE AND KHEDIVE MINE AND MILL. The Bachelor contained high-grade silver ore in pockets, and the production capped $4 million in ore. A concentrating mill for low-grade ore was erected. This 1900 photograph shows the mill at the right connected with a covered rail and trestle to the Khedive portal on the top left. (OCHS.)

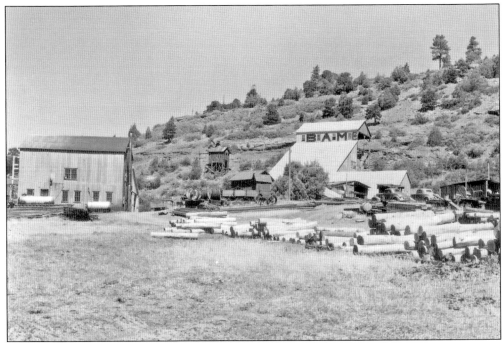

BANNER AMERICAN MILL. In 1931, G. A. Franz Sr. opened a mill north of town near Lake Lenore. The mill provided employment for the citizens of Ouray during the Depression; Franz had the largest payroll in the community. The flotation mill had a capacity of 250 tons of ore daily. The mill closed in 1952. Panorama Heights, a housing development, is located on the former mill site. (DPL, #X-5645.)

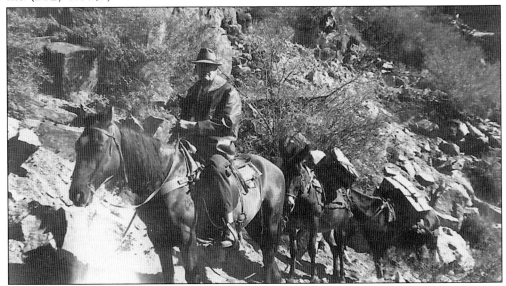

CHIEF OURAY MINE. Around 1939, John Bell led a pack string up the steep 2.4-mile trail above Cascade Falls to the Chief Ouray Mine; all the supplies for the entire operation came up this trail. The mine was opened by Lars Pilkar, and he hired Roy Chadwell as the mine boss. During World War II, the War Production Board ceased gold mining operations, and the Chief Ouray Mine closed. (Bryl Keith Chadwell.)

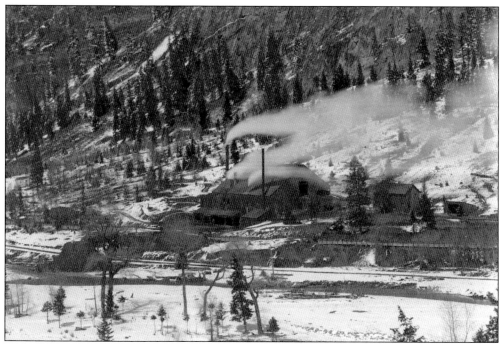

FOWLER SMELTER IN 1890S. Most of the ore from the Ouray mines was shipped to smelters outside of the district, but at least six smelters were built near Ouray. The Fowler smelter, built north of the city, was only in operation for four years. Acrid smoke poured from the stacks. To make local smelters unprofitable, the larger smelters temporarily lowered their prices. The discouraged W. H. Fowler returned to Chicago, and his smelter was demolished. (OCHS.)

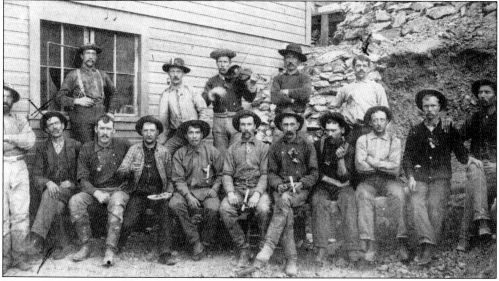

MICKEY BREEN. Located by Milton Cline, the first mayor of Ouray, the Mickey Breen was situated up the Uncompahgre River on the Engineer Pass Road. F. W. Pitkin, who would later become governor of Colorado, had a stake in the mine as well. These miners probably gathered for a group shot early in the morning, and each had his own candlestick for illumination underground. Miners gradually switched to carbide lamps after the turn of the 20th century. (OCHS.)

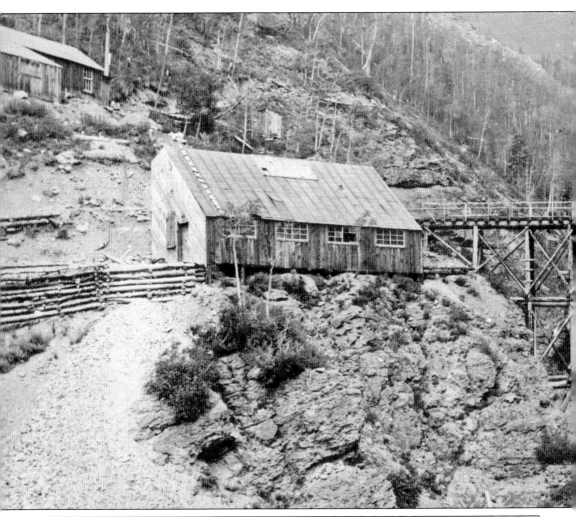

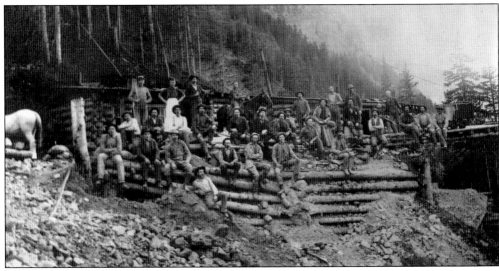

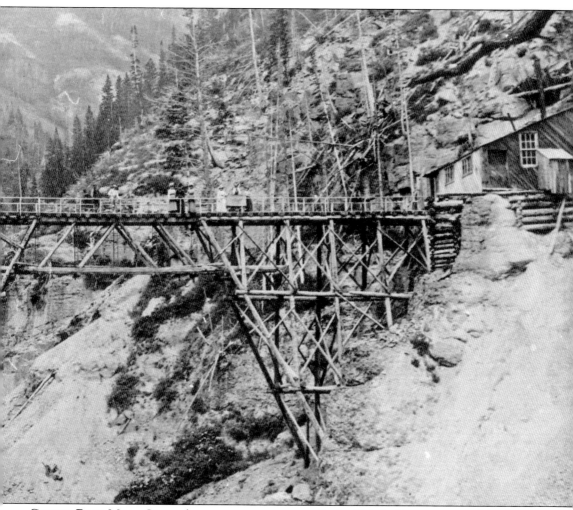

GRIZZLY BEAR MINE. Situated up a remote, narrow trail, the Grizzly Bear was one of the first mines staked in Ouray County. It produced about $600,000 in the early years, but the difficulty of using pack burrows to transport ore and supplies was expensive and dangerous. No wagon ever reached the site. In the above photograph, a trestle connected the boardinghouse to the mine workings. At left on the opposite page, miners rest outside the tunnel. An ore cart on rails waited. Pictures of posing miners in front of portals and boardinghouses were used to promote mines to investors. (Both Bud Zanett.)

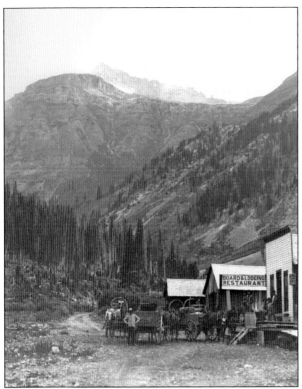

CHATTANOOGA. Located on the San Juan County side of the Continental Divide near the Silver Crown Mine, Chattanooga had a fast start in 1883, with 75 buildings thrown up in just a few months. An avalanche slid out several buildings in 1888, and then in 1892, a fire burned up the rest. Most of the residents had moved on to Red Mountain Town when this photograph by William Henry Jackson was taken. (OCHS.)

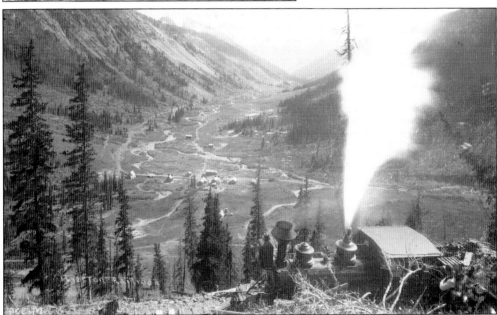

CHATTANOOGA LOOP. The Silverton Railroad started the steeper part of its climb up Red Mountain Pass with this famous "loop." Bear and Sultan Mountain are visible in the distance. The view is to the south, winding down the U-shaped glacial valley following Mineral Creek. The railroad made a 550-foot climb in a quarter of a mile from here to the crest of the Red Mountain Pass. Otto Mears's engineer, Wingate Gibbs, laid this track out in 1888. (DPL, #1430.)

TOWN OF CONGRESS AND THE CONGRESS MINE. Located just south of Red Mountain Pass, Congress was hastily laid out while 6 feet of snow covered the ground. Congress was an unorganized town from the start, and with Red Mountain Town looking more prosperous, most of the citizens packed up their cabins and moved there. By 1887, only a handful of men remained. Pictures of Congress are very rare; Roger Henn, Ouray historian, donated this 1883 photograph to the Ouray County Historical Society. (OCHS.)

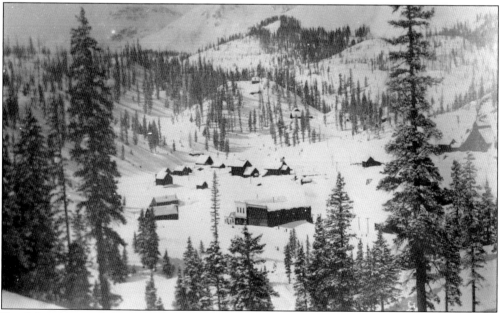

RED MOUNTAIN TOWN. In this winter scene, the town was at its peak population, the National Belle was producing silver and copper, and the streets were lined with businesses. On August 10, 1892, a fire broke out in a hotel and the close-together, dry-framed buildings burst into flames. The town was never completely rebuilt. The population stood at around 500 in 1887, but the 1910 census counted only 26 Red Mountain Town residents. (OCHS.)

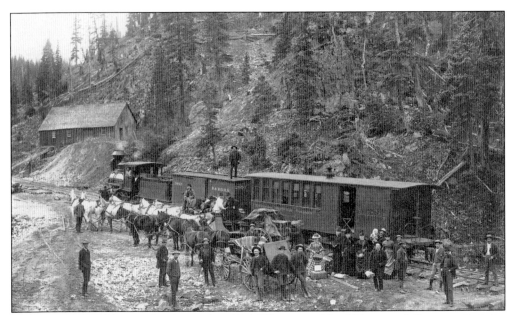

FIRST PASSENGER TRAIN. On September 19, 1888, engine No. 100, named Ouray, pulled the first passengers into Red Mountain Town from Silverton—a distance of 17 miles. Otto Mears is standing next to the steps on the back car and C. W. Gibbs, chief engineer, is the third man from the right. Two stages and a buggy would transfer the passengers down the steep canyon to Ouray. Mears charged 20¢ per mile for passengers. The Silver Panic of 1893 wreaked havoc on Mears's business ventures. (DPL, #Z-5488.)

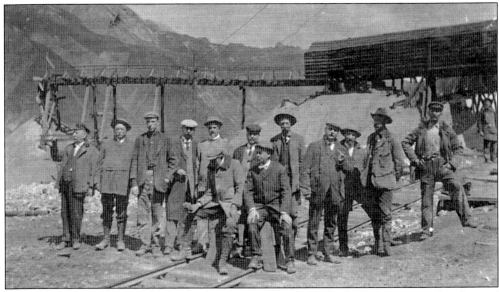

GENNESSEE VANDERBILT CREW. Dressed up in their Sunday best, these miners posed in front of the dump trestle, which carried the waste rock out of the mine and onto the mine dump. The Gennessee-Vanderbilt Mine was located across the canyon from the Treasury Tunnel, the current site of the Idarado Mine. Faced with increasing mine water like many of the shafts in the Red Mountain area, it closed in 1899 but was later accessed beginning about 1907 by the lower Joker Tunnel and was worked sporadically until the 1940s. (OCHS.)

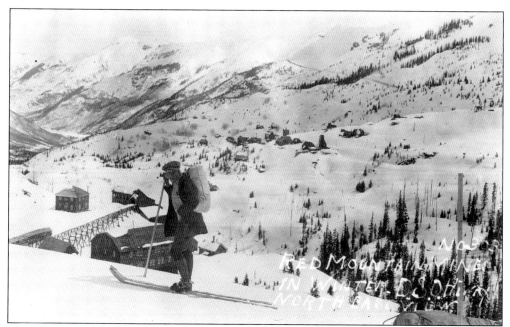

MAIL CARRIER. A lonesome man on skis carrying a sack of mail paused to look at the Red Mountain Mines across the valley. The head frame of the Yankee Girl mine is visible in the distance, and the Treasury Tunnel stretches out below and to the left. (OCHS.)

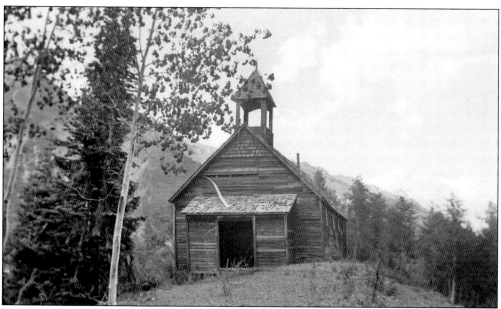

GUSTON'S CHURCH. In 1891, the citizens of Guston decided that civilized folks needed a church. They invited an Englishman, Rev. William Davis, to become their pastor after the town of Red Mountain turned him down. Davis erected the church himself and lived in a small cabin nearby. Right after the church was dedicated, Red Mountain Town burned. This 1941 photograph was taken when the church was in ruins; it no longer stands. (DPL, #X-3743.)

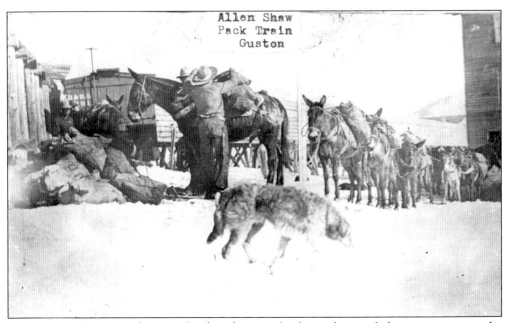

BURRO PACK TRAIN AT GUSTON. In this photograph, the pack train led to an ore car on the railroad. The ore was shipped out in boxcars. It was too valuable to be shipped in open cars. Burros were not tied head-to-tail like mules but were driven from the rear. Ore sacks with concentrate were carefully and equally distributed on each burro's back (OCHS.)

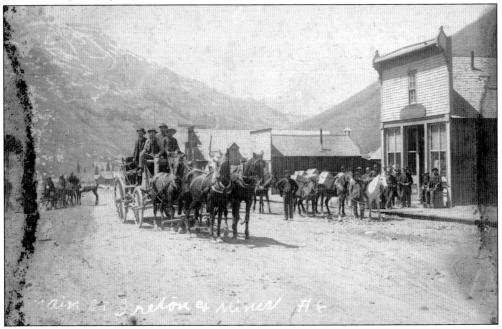

IRONTON, LATE 1880s. Several mines were located in Ironton Park, and the town became the largest community in the district. Unlike most helter-skelter mining camps, Ironton was officially platted on a grid. The area was stripped of trees as sawmills worked overtime. The main street, named Ouray, ran for almost a mile. The Albany Mill, terminus of the Silverton Railroad, was located about half a mile north. (Ruth and Marvin Gregory collection.)

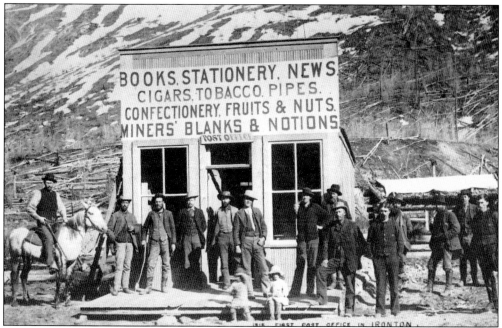

IRONTON POST OFFICE. In 1884, Ironton had a post office, 12 saloons, four restaurants, and a newsstand that sold tobacco and fruit. By 1890, the population had reached 323. These men lined up in front of the post office are perhaps waiting for the mail delivery. Letters and newspapers from back home filled lonely hours. (OCHS.)

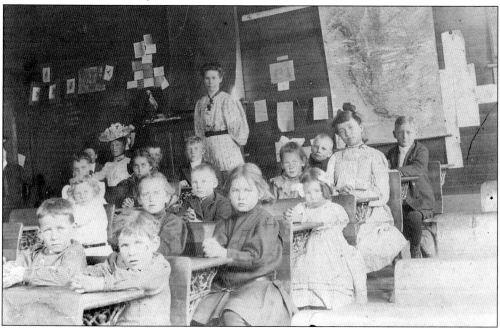

IRONTON SCHOOL. Unmarried women taught all the grades together, and students usually attended school until the eighth grade. Here Nellie Stevens's pupils, with folded hands, are attentively sitting in their desks. She has placed a map of North America on one wall; Geography was an important subject, as these isolated children had no other way to learn of the world outside. (OCHS.)

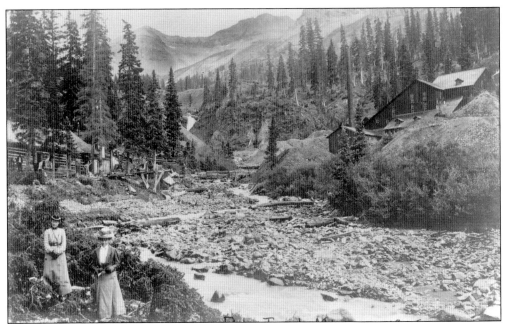

RUBY TRUST, 1895. Some say the Ruby Mine got its name because of its beautiful specimens of Ruby Silver, which captured the attention of mine investors. Others say it was named for a miner's sweetheart. Either way, this mine's rich silver soon petered out. Fire and snow slides plagued the mill and boardinghouse, but in 1934 the mine and a small mill operation were put back into production. However, Frank Rice, in his book *The Mines of Ouray County*, remarked that, "During Prohibition days . . . it was generally believed that the output was measured in gallons, rather than in tons." (DPL, #X-61996.)

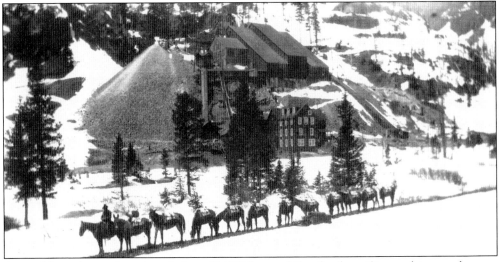

ATLAS MILL. At an elevation of about 11,000 feet and 8 miles from Ouray, this complex was located on a spur off the road to Yankee Boy Basin, just beyond the Revenue Mine. A stamp mill, it operated from 1900 to the mid-1920s. A four-story boardinghouse sat at the base of the mill. Boardinghouses were often constructed off site, the boards individually numbered and brought up to the mine site to be rebuilt. The mill used electricity from Telluride's Ames power plant. (OCHS.)

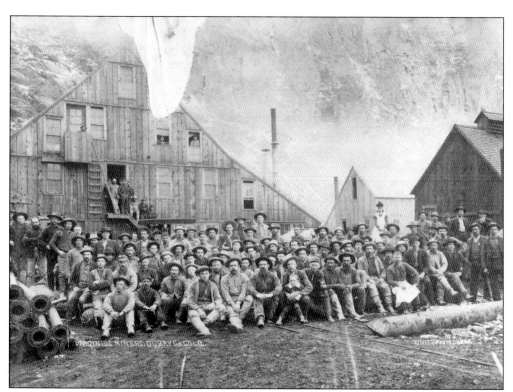

VIRGINIUS MINE. The Virginius Mine was situated 2 miles southeast of Mount Sneffels. Its location above timberline made mining extremely difficult, but the Virginius was one of the most profitable mines in the San Juans. Here about 100 miners are grouped in front of their three-story boardinghouse. (DPL, #X-62119.)

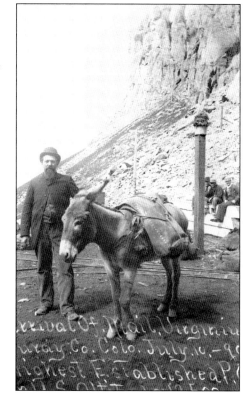

MAIL ARRIVES. On July 10, the mail arrived by burro at the Virginius post office. Above timberline at an altitude of 12,500 feet, it held the distinction of being the highest established post office in the U.S. (OCHS.)

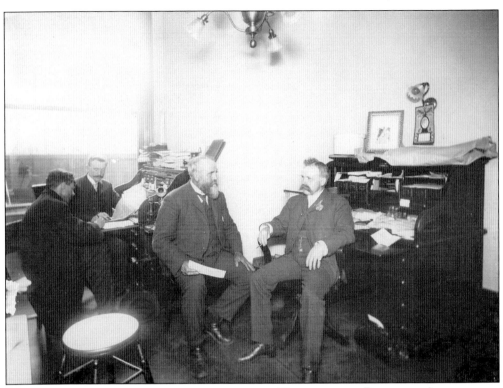

THATCHER AND REYNOLDS. A. E. Reynolds was one of the most consequential mine owners in the state. The friendship between Mahlon D. Thatcher and A. E. Reynolds lasted a lifetime. Thatcher and his brother John opened the Miners and Merchants Bank in Ouray, one of 18 banks they owned in Colorado. A financier and empire builder, Thatcher served on the Board of Directors of many of Reynolds's enterprises. Reynolds (left) and Thatcher (right) sat in deep conversation in this unknown office. Reynolds purchased the Virginius in 1879 for $100,000. (OCHS.)

DORA EARLL REYNOLDS. When A. E. Reynolds turned 41, he decided that the time was right to marry. In 1883, he met and married Dora Earll from Columbus, Wisconsin; she was 31 to his 43. They lived in the Capitol Hill area of Denver but never owned a home in Ouray, the city that helped make them millionaires. The couple had one daughter, Anna. (Colorado Historical Society.)

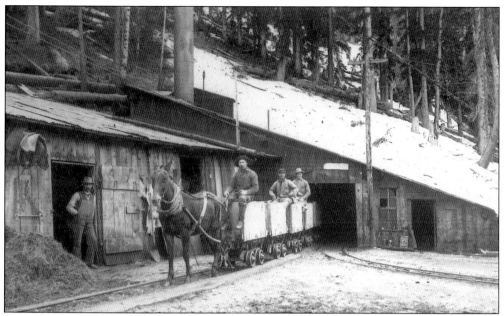

REVENUE TUNNEL. In 1888, Reynolds commenced driving the Revenue Tunnel. The portal was located at the small settlement of Porters (later named Sneffels). The intention was to intersect the Virginius Vein, haul the ore out at a much lower elevation, and freight the ore to Ouray for shipment. A mule-drawn ore train leaves the portal in this William Henry Jackson photograph. (OCHS.)

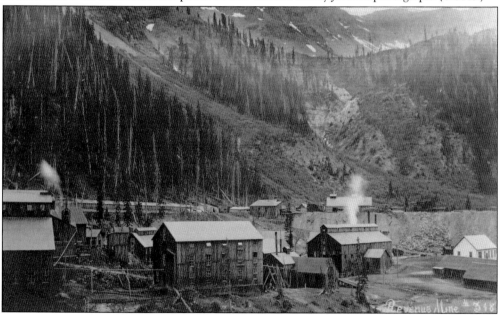

REVENUE MILL. Once the Revenue Tunnel was completed, construction on the mill began in 1894. By 1896, the mill proved inadequate to handle the huge amount of ore being mined. An addition to the mill was constructed on the south side of the original mill. It produced 15 tons of concentrated ore a day. A covered track carried ore from the portal of the tunnel to the mill. Felled trees and stumps dotted the hillsides. The mill operated for approximately 25 years and produced $15 million in ore between 1900 and 1920. (OCHS.)

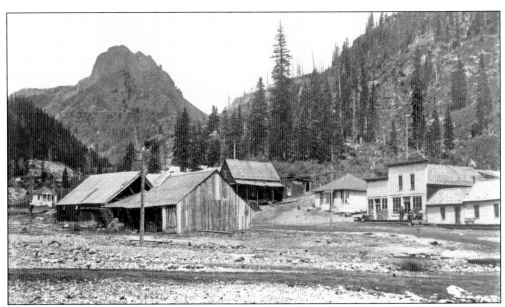

JOHN ASHENFELTER STABLES. Ouray had opportunities, and Reynolds was instrumental in convincing Ashenfelter to relocate there. Ashenfelter not only had a huge freight operation at the Revenue, but he also rented horses to the miners who wanted an evening off in Ouray. Ashenfelter's stables are located to the right; the boardinghouse is in the center. (OCHS.)

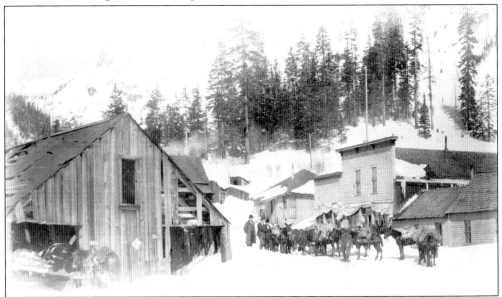

SNEFFELS. During the boom years of operation for the Revenue-Virginius, a community arose nearby. First called Porters for George Porter, who established a store there in 1877, the name was changed to Sneffels (for the nearby peak of Mount Sneffels) after Porter's death in 1895. In the distance is the fogged-in Stony Mountain. The store and post office have false fronts with awnings. John Ashenfelter's barns are on the left. The photograph reads, "Uncle John and partners with pack mules. 1886–1892." When the Hayden Survey mapped the region in 1875, they named the mountain after the volcano Snaefell located in Iceland. This mountain was featured in the novel *Journey to the Center of the Earth* by Jules Verne. (OCHS.)

SNEFFELS POST OFFICE, 1884. For most miners, time off meant sharing the tipping of a glass of wine or beer. Originally built as a crude log cabin (as seen in this photograph), the post office building was later covered with wood siding. It closed in 1930. (OCHS.)

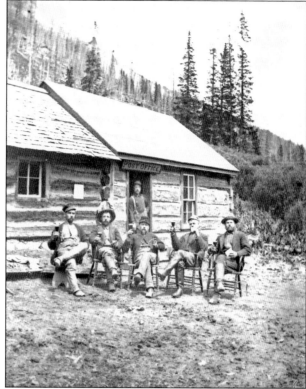

JULY 4, 1902. The wife of Sneffel's postmaster George Van Horn took a winter carriage ride in the middle of the summer of 1902. The altitude at Sneffels was 10,610 feet, and summer came rather late. George Van Horn was a cousin of A. E. Reynolds. (OCHS.)

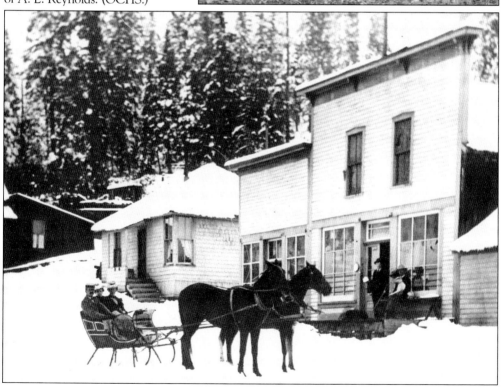

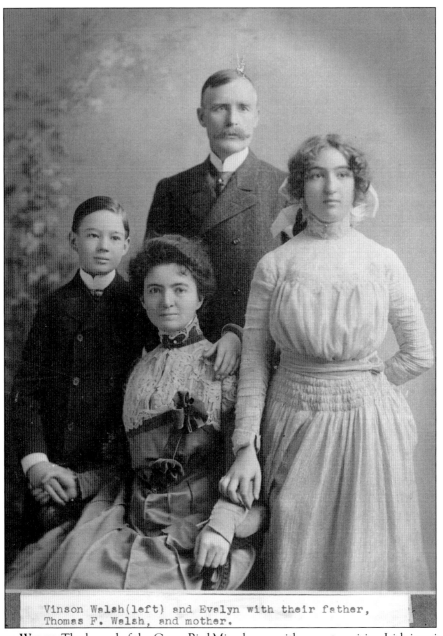

Vinson Walsh (left) and Evalyn with their father, Thomas F. Walsh, and mother.

Thomas Walsh. The legend of the Camp Bird Mine began with an enterprising Irish immigrant, Thomas Walsh. In 1896, Walsh sifted through some abandoned silver mines in the Imogene Basin, 6 miles southwest of Ouray. Intrigued, he hired Andy Richardson to sample some galena-streaked veins, and the assay came back with astonishing news: the ore ran as high as $3000 in gold to the ton. With silver prices low, Walsh quietly bought up the surrounding claims. Tom Walsh moved his wife, Carrie; his daughter, Evalyn; and his son, Vincent, to Ouray. Years later, his daughter, Evalyn Walsh McLean, told the tale of her father's discovery of the Camp Bird Mine in her autobiography, *Father Struck it Rich*. Tom had called her into his room and whispered the words, "Daughter, I've struck it rich." His premonition was true. The Camp Bird Mine made Walsh a multimillionaire. (OCHS.)

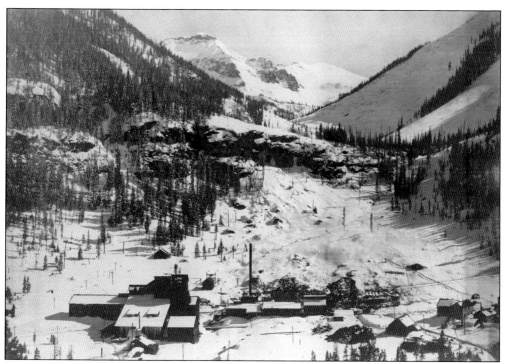

WALSH'S CAMP BIRD MILL. Development of the mill proceeded. By 1898, a concentrating mill was in operation. By 1899, the 20-stamp mill was increased to 40 stamps. The mill ran 24 hours a day and chugged out as much as $5000 a day in profits between the years 1896 and 1902. (OCHS.)

"THE SIXES," BEFORE 1900. Wagons loaded with mill concentrates leave the Camp Bird mill headed for the Ouray depot and on to a smelter in Pueblo. Teams of six or eight horses pull the wagons. Two mule trains left the Camp Bird mill every day. Two sacks of gold concentrates left the mine every day as well, escorted by armed guards and shipped to the Denver Mint. (OCHS.)

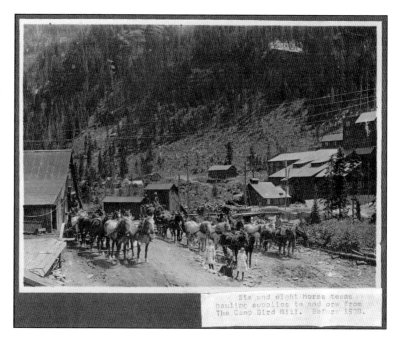

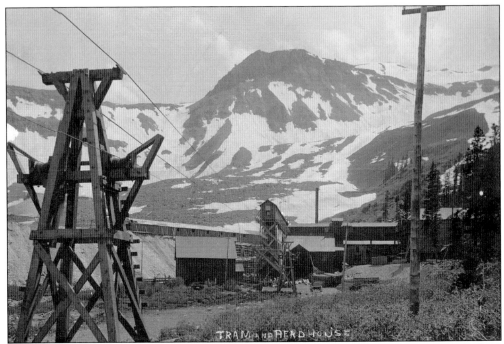

TRAM LINE. In just 48 days, tram builder E. H. Taylor constructed the 11,000-foot Bleichert bi-cable aerial tramway. Eventually, the tram connected thousands of feet of tunnels to the mill 2 miles below. Each bucket carried 700 pounds of ore, and the tram could haul 12 tons per hour. Chicago Peak is above and to the south of the level-three workings. (OCHS.)

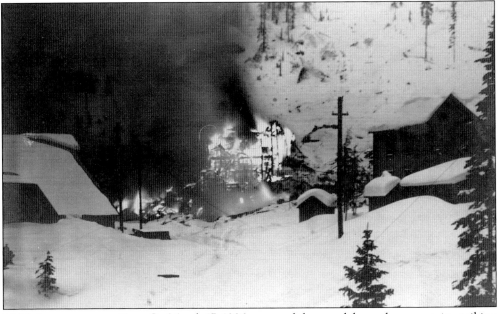

1906 AVALANCHE AND FIRE. On March 17, 1906, a snow slide roared down the mountain, striking the mill. The mill was damaged but survived; nonetheless, three days later, a fire starting in the boiler room and completely destroyed the mill. By November of that same year, a new 60-stamp mill was erected. (OCHS.)

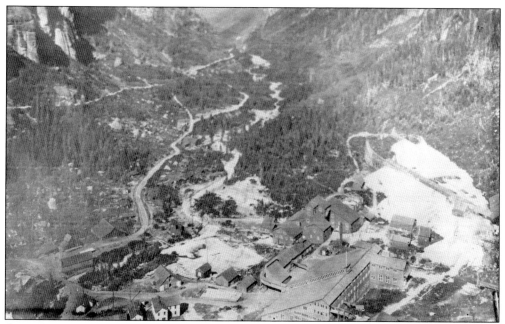

CAMP BIRD COMPLEX. The rebuilt mill stands to the lower right of this photograph. A cyanide mill was added to process tailings that contained lower grade ore. As the mine was dug deeper into the mountain, gold values decreased; mining was suspended in 1916 until a lower tunnel could be built. This view looks towards the city of Ouray. (OCHS.)

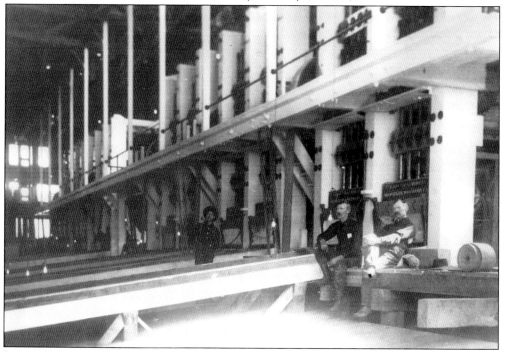

INSIDE CAMP BIRD STAMP MILL. Two mill men sit near the powerful stamp batteries that crush the rock into small particles. The stamps weighed 850 apiece. Mercury later bound the bits of gold into droplets. The row of stamps continues across the photograph. (OCHS.)

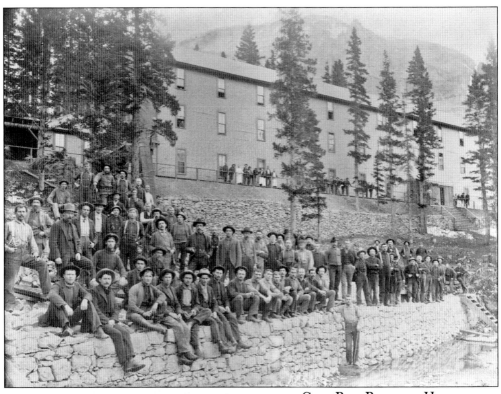

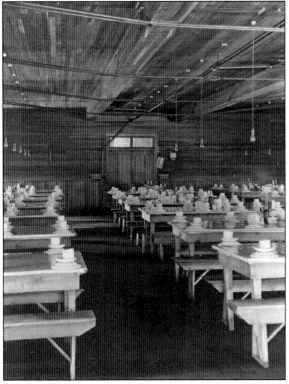

CAMP BIRD BOARDING HOUSE. Walsh erected a three-story boardinghouse. With marble-topped washbasins supplying hot and cold running water, white-enameled iron beds, and porcelain tubs, the miners lived in hotel-like quarters. Electricity and steam heat made the men more comfortable in the dark, snowy months. Room and board cost $1 a day. Miners received $4.50 a day, blacksmiths $4, and engineers $4.50. The mine employed up to 500 men during the Walsh years. (OCHS.)

DINING ROOM. The Camp Bird dining room sported china dishes on well-organized tables. The cook was often said to be the most important employee of the mine. Miners' taste buds were dulled by years of working in dust; highly flavored dishes such as sauerkraut and pickles as well as hardy meat and potato dishes provided sustenance. (Ruth and Marvin Gregory collection.)

WAIT STAFF. Dining-room waiters dressed in ties and white aprons. Sometimes musicians played in the background. (Ruth and Marvin Gregory collection.)

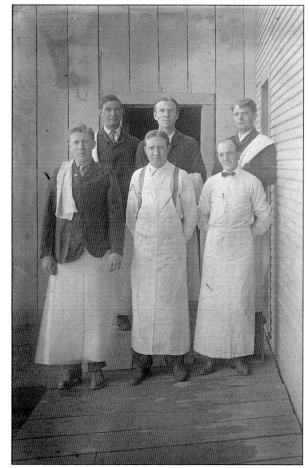

CLUB ROOM. Often snowed in during the winter months, the miners spent their off-hours playing pool, listening to phonograph records, or perhaps reading in cushioned chairs. Walsh subscribed to various newspapers and magazines. In an era when 12-hour shifts were the norm, Walsh's employees worked just eight hours a day. (OCHS.)

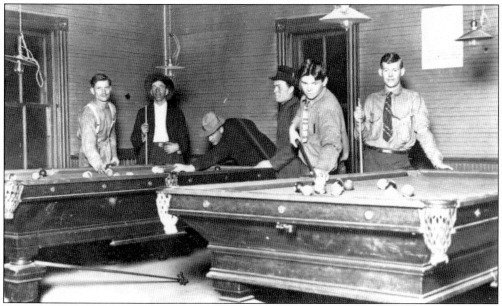

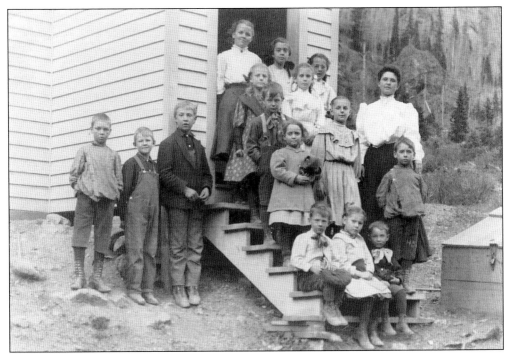

CAMP BIRD SCHOOL. A small settlement called Potosi sprang up around the mill with cottages, stores, and a school. In 1903, children pose with their teacher, Emma Hagere, in front of the one-room schoolhouse. At one time, 19 families lived at the mine, but as was the case with mining camps, the majority of the men were single. (OCHS.)

GIRLS IN TENT. Three young women pose in front of a tent pitched at the Camp Bird. The occasion is long forgotten, but the woman on the right has a hairpin in her hand. (OCHS.)

WALSH'S CAMP BIRD OFFICE. Walsh leans back in his chair, perhaps contemplating the sale of his mine. His failing health and the hard winters made the decision easy. In 1902, he sold the Camp Bird Mine to a London Syndicate for an estimated $6,000,000 counting royalties. (The mine had produced $2,400,000 in profits from 1896 to 1902.) At the time of the sale, the mine was the largest and richest mine owned by an individual in the world. (OCHS.)

EVALYN WALSH MCLEAN AND THE HOPE DIAMOND. Evalyn loved jewels. After Tom's death, she purchased the most famous diamond in the world for $154,000. But it seemed that the diamond carried a curse. Her son was killed after being struck by a car, a daughter died of an overdose of sleeping pills, her granddaughter died of alcohol-barbiturate poisoning, and her husband, Ned, drank until he became insane. (OCHS.)

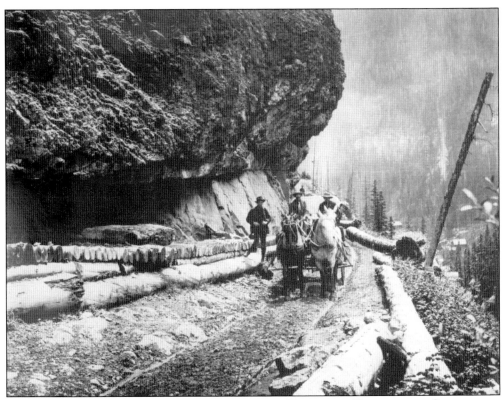

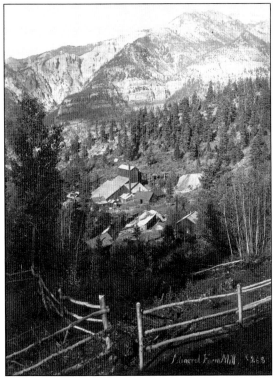

FREIGHTING BETWEEN THE CAMP BIRD AND REVENUE MINES. In the late 1890s, wagons piled high with supplies, machinery, or ore weighing as much as 9000 pounds filled this road seven days a week. Hanging Rock was a popular stopping point for photographs. The canyon plunged several hundred feet down to level 14 of the Camp Bird Mine, where the mill and offices were located. (OCHS.)

MINERAL FARMS MINE AND MILL. Gus Begole and Jack Eckles were credited with being the founders of the city of Ouray and of this mine, one of the first claimed in the area. Mineral Farms was stumbled upon a short distance from Ouray up Canyon Creek by Gus Begole and Jack Eckles. It got its name because the ore was found in pockets and was so close to the surface that it could be dug like potatoes. Not until the 1930s did production cease. Today a subdivision sits on the site. (OCHS.)

Four

The Golden Age in a Victorian City

Most mining camps never evolved into substantial communities, but Ouray did. Attributing to its success was a set of factors. Ouray became the regional supply town for several profitable operating mines and mining districts. It was the county seat. Hastily erected lumber buildings were replaced with substantial stone or brick structures. The railroad arrived in 1887, lowering shipping costs. Telephone service arrived in 1882, and electricity came in 1885.

In the last decades of the 19th century, Ouray had as many as 30 saloons. Some merely provided a public place for lonely miners to socialize on a Saturday night, while others offered gambling and prostitution. One reason there were so many saloons was because of the number of ethnic groups that populated the town. Men with different occupations such as freighters or railroaders frequented different saloons. Establishments with names like The Bird Cage, The Monte Carlo, the Bon Ton, and The Club, as well as a line of prostitutes' cribs filled Second Street between Seventh and Eighth Avenues. Over 100 girls worked the red-light district, in as many as 16 brothels.

Simultaneously, a less buttoned-down Victorian society was in full swing. Tom Walsh hosted balls at the Beaumont Hotel, and the newspapers gave flourishing reports of elaborate society weddings and dinner parties.

Ouray's economic classes became more stratified. Mine owners and managers as well as successful merchants, and professionals like Tom Walsh, Marshall Orendorf, and Judge Story became wealthy while laborers worked for moderate wages, mainly in the mines. The Beaumont Hotel opened in 1886 and catered to mining investors, wealthy tourists, and salesmen. Banks offered credit to their customers and financed business and mining adventures.

By 1890, the population was 2,000, mining peaked, and Ouray's future was bright until the silver crash that followed the repeal of the Sherman Act in 1893. Operating gold mines, especially the Camp Bird, kept the economy from completely collapsing, but many businesses failed, silver mines closed, and the town's population decreased.

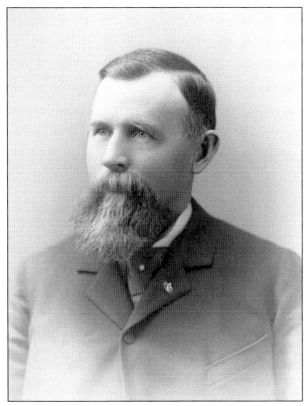

COMMON-SENSE STATESMAN FROM THE SAN JUANS. A stonemason by trade, Francis Carney prospered as a building contractor. The clay deposits located north of town were suitable for brick making, and in the early 1880s, he constructed a brickyard where the present-day Ouray Hot Springs Pool is located. In 1879, Carney began a political career by first being elected county commissioner, then state representative, and state senator. In 1898, he was elected lieutenant governor of Colorado. Carney was a friend of the labor unions. The below picture shows bricks lined up in neat rows, drying in the sun. Carney provided bricks to the mines and, in 1882, built the first brick building in town, the Hartwell building. This was followed by the county courthouse, the Wright Opera House, Miner's Hospital, St. Elmo's Hotel, and City Hall. (Both OCHS.)

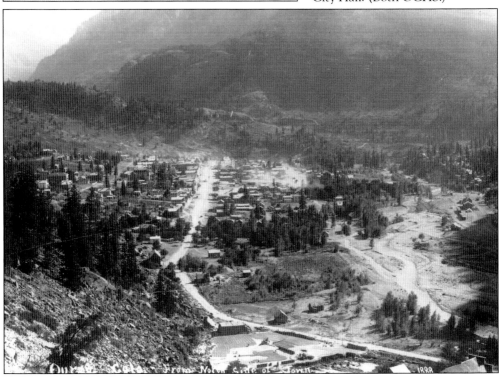

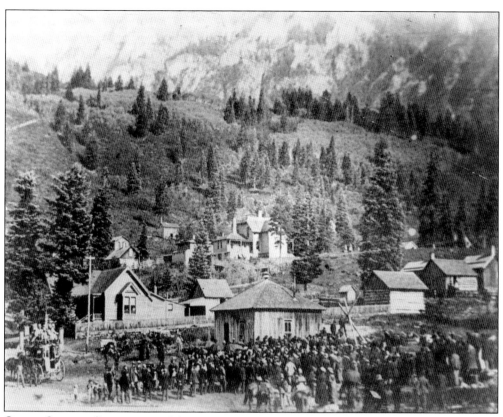

OURAY COUNTY COURTHOUSE. Mining camps produced an abundance of records as claims were filed, sold, and resold. Running out of room in their rented space, the commissioners purchased this site for a permanent courthouse and asked the Masons to lay the cornerstone. On August 22, 1888, townspeople gathered for the dedication ceremony. Several of Ouray's finest gathered for a photograph on the front steps of the courthouse. Below, Dr. Rowan is seated in front, Walter Wheeler is seated behind Rowan with his hat tipped back, and Judge Rathmell is standing on the left side of the porch, leaning on a pole. (Both OCHS.)

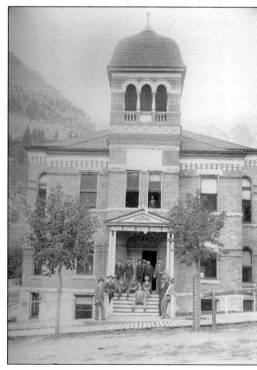

PHOTO BY RINEHART
LIEUT.-GOV. WILLIAM STORY

JUDGE WILLIAM STORY. Judge Story served as the chief justice of the Arkansas Supreme Court, but for unknown reasons, he migrated west. He landed in Ouray in 1877 and immediately began a law practice and served as attorney for both the city and county. Story also dabbled in mining, banking, and power companies. By 1888, he was appointed judge of the Seventh Judicial District. In 1890, Judge Story became the second man from Ouray to be elected lieutenant governor of Colorado. (DPL.)

THE STORY BLOCK, 1895. Louis King erected this stone building after his original frame structure burned. During the 1893 Silver Panic, King lost his building to foreclosure, and Judge Story purchased it. Upstairs, the Wilson Hotel operated for 50 years. Downstairs, tenants included The Bank Café and Saloon and a clothing store. (Note the reflection of the photographer's tripod in the window.) This building is also pictured on page 100. (Ruth and Marvin Gregory collection.)

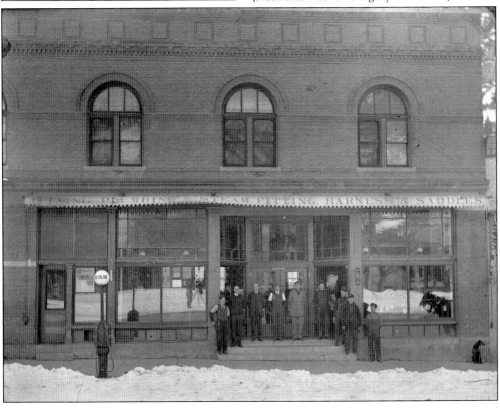

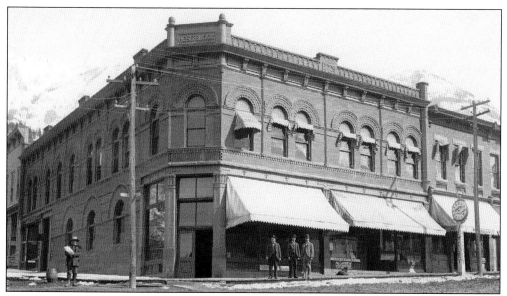

HESS BLOCK AROUND 1910. No gambling was allowed in Theodore "Pat" Hess's saloon, but a man could buy a drink and a cigar and shoot billiards there. In 1893, Hess erected this brick structure on the corner of Main Street and Sixth Avenue after his frame building burned a year earlier. (OCHS.)

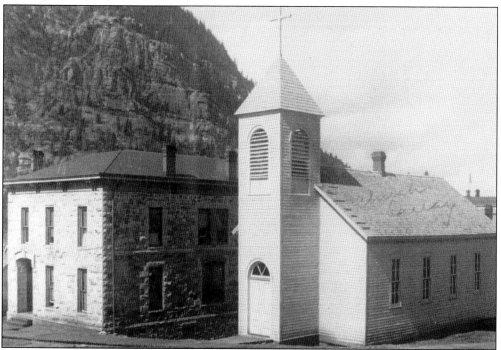

MINER'S HOSPITAL. The Order of the Sisters of Mercy opened Miner's Hospital in 1887. Cases of "miner's con" or silicosis were rampant, and epidemics were common. The hospital was threatened with foreclosure after the Silver Panic, but Thomas Walsh, owner of the Camp Bird Mine, paid off the mortgage. St. Patrick's Catholic Church stands to the east of the building. Today the building houses the Ouray County Museum. (OCHS.)

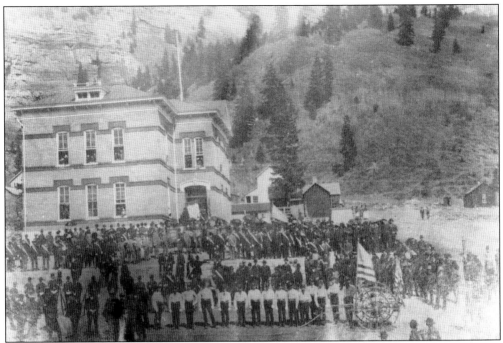

DEDICATION OF RED BRICK SCHOOL. The community came out for the dedication of their new school in 1893. The Ouray Hose Company (front row) and lodge members in uniform stood at attention during the ceremony. Student enrollment had reached 390. (OCHS.)

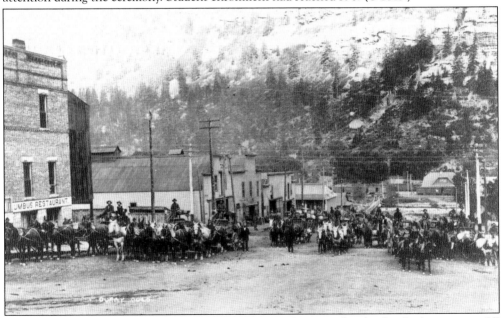

ASHENFELTER'S TEAMS, 1892. Mule and horse teams of sixes and eights hitched to wagons fill Eighth Avenue in this photograph. John Ashenfelter owned the largest freighting operation in Ouray. He hauled ore from both the Revenue and Camp Bird Mines and kept 80 burros in his livery barns for use on pack trails. Ashenfelter's barns are to the left of this picture behind the Columbus Restaurant. The depot is in the distance. (DPL, # X-12822)

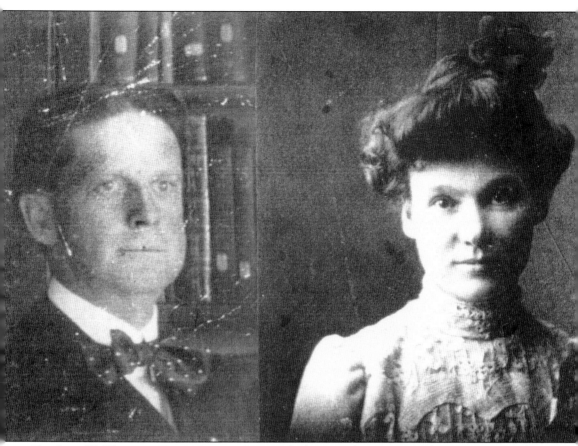

Dr. John H. Hereford. In 1888, young Dr. Hereford accepted a position at the Miner's Hospital shortly after his graduation from medical school. A year later, he married his sweetheart, Mollie, in St. Joseph, Missouri. Upon their arrival in Ouray, a celebrating crowd met them at the train station. The couple was soon expecting their first child. Meanwhile, in his medical practice, the young doctor began dabbling in an experimental medical treatment called Brown-Sequard. Dr. Hereford believed that by grinding up and filtering organs from animals and injecting the solution into his patients, he could cure aliments. He did inject his concoction into both animals and humans, but nothing is known of the outcome. On March 3, 1890, Mollie gave birth to a stillborn baby. The Silver Panic hit his practice hard, and the couple moved to Cripple Creek in 1894. (OCHS.)

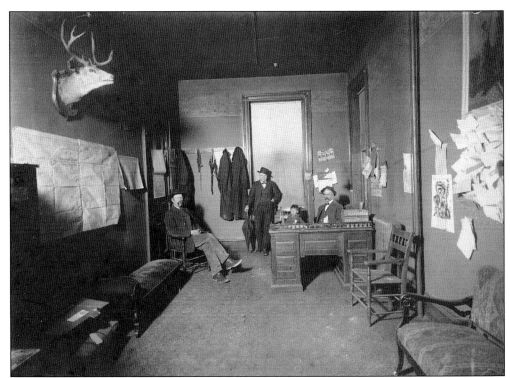

MAURICE CORBETT, SHERIFF. Corbett came to Ouray in 1884 and served as sheriff of Ouray County from 1902 to 1908. Corbett sat at his desk in this photograph with his young son, John, beside him. Corbett was well known for his nerves of steel, especially after he faced down a group of 75 angry miners set on destruction at the Virginius Mine. (OCHS.)

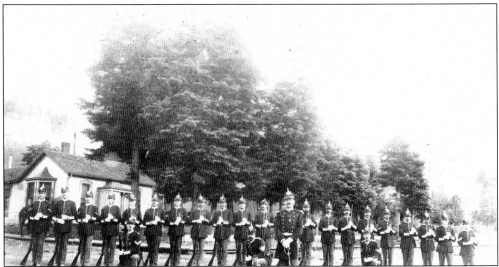

COMPANY K, SECOND BATTALION, OURAY NATIONAL GUARD, 1887. Little is known about this short-lived militia that was formed to protect the town from Ute uprisings. In 1887, the so-called Colorow War erupted when a band of Utes left the reservations to hunt near Meeker. The men of company K never left Ouray, but they did march in the Fourth of July parades, and the Company held receptions and "hops" where a young woman could dance with a man in uniform. (OCHS.)

THE ROMONA SCHEME. George A. Jackson made a name for himself before he came to Ouray. A fifty-niner, he headed up Clear Creek Canyon near Denver, struck it rich, and founded the town of Idaho Springs. By the 1880s, Jackson settled in Ouray. In the middle of a pasture north of town, he started construction on a large stone house. Together with several other prominent citizens, including newspaperman Dave Day, he made plans to build a town on this site called Ramona that would become the terminus of the new railroad line, in effect cutting off the city of Ouray. Their scheme failed. Jackson's Queen Anne and Italianate-designed home was the finest structure in Ouray County and still stands. This photograph of Jackson's house was taken during the time the home served as the county "poor farm," between 1914 and 1937. (Right, DPL; below, OCHS.)

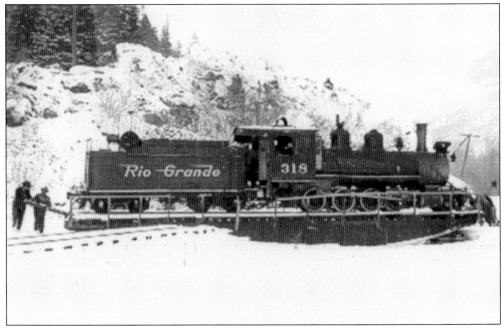

THE DENVER AND RIO GRAND RAILROAD ARRIVES. A 36-mile stub line from Montrose arrived in Ouray on September 28, 1888. The Ouray branch was the end of the line. The railroad crews used a manually operated Armstrong turntable to rotate the engine so the train could steam back to Montrose. Ouray's young boys thought it great fun to ride with the engineer while the train was being turned. (Karl R. Schaeffer.)

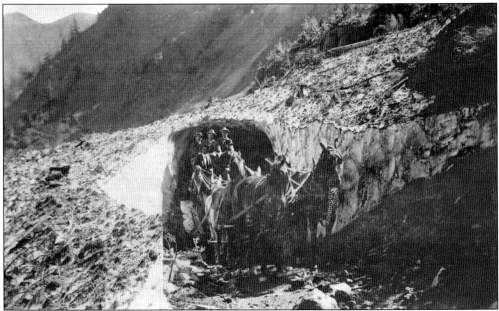

RIVERSIDE SNOW TUNNEL, 1894. The Riverside slide, about 4 miles south of Ouray, has earned the distinction of being the most treacherous avalanche between Ouray and Silverton. In the years before snow plows, a 300-to-400-foot ice tunnel was dug through the slide every winter. The snow lasted until July or August. Even a six-horse stage could travel through it. (OCHS.)

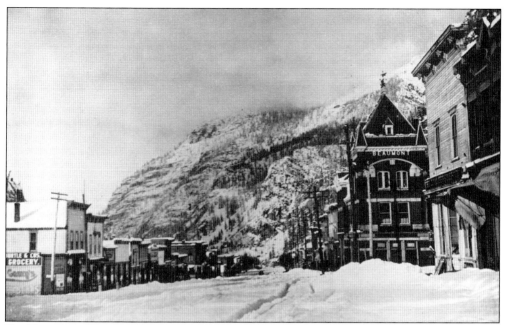

THE BEAUMONT HOTEL, "FLAGSHIP OF THE SAN JUANS." Completed in 1886 at a cost of $85,000, the Beaumont was an elegant addition to Ouray's Main Street. Financiers from the East Coast as well as salesmen, politicians, and middle-class tourists stayed at the hotel. Women used a side entrance to keep them away from the gentlemen's bar. Rooms rented for $3 to $4 a night. (OCHS.)

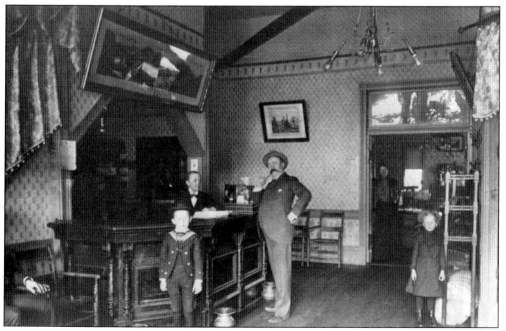

INSIDE THE LOBBY OF THE WESTERN HOTEL. Built in 1891, the three-story hotel rented rooms for $1.25 to $1.50 a night. The hotel rented up to 43 sleeping rooms with three toilets and one bathtub used by guests and the family. The building is the largest frame structure of its era still standing in Colorado. (Rose Marie and Gregg Pieper.)

ALFRED KING, MILTON OF COLORADO. When King went to work in the Calliope Mine in 1890, he was a young man. A serious explosion left King blinded and hearing impaired. King turned to poetry. His popular poems were widely read, and he lectured, played the flute, and sold his books all over Colorado. The poems in *Mountain Idylls* told of miners, mountains, and the opening of the West. (OCHS.)

LOOKING ACROSS OURAY COLORADO. In 1898, Edith Fowler took in the view from Oak Creek Reservoir. The Beaumont Hotel can be seen in the distance, and Cascade Falls rushes off the mountainside. The reservoir provided water to the western part of town. (OCHS.)

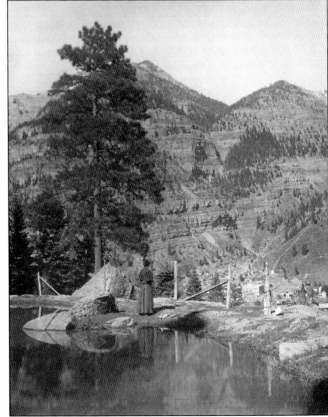

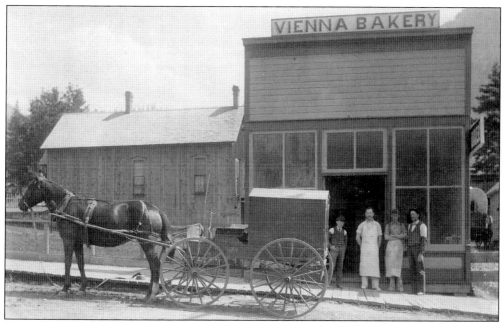

MARSHALL ORENDORF AND THE VIENNA BAKERY. In the late 1890s, Marshal Orendorf opened the Vienna Bakery. He hired a professional baker to make all types of pies, cookies, bread, doughnuts, and rolls; his delivery wagon took his goods directly to the streets and homes of Ouray. This 1897 photograph shows his bakery located on Sixth Avenue across from today's Ouray City Hall. In the below picture, Orendorf sits in his office in the Wilson Hotel. Orendorf's business success continued as he opened mercantile stores in Norwood, Nucla, Silverton, Montrose, and Ridgway. (Both OCHS.)

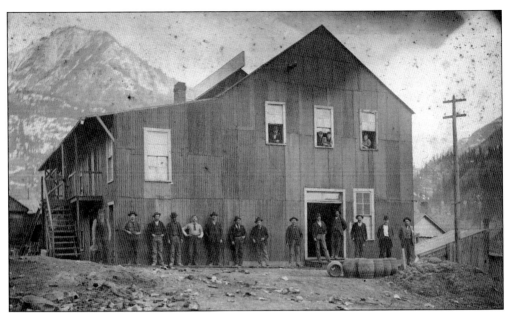

THE GOLD BELT THEATER. This shed-like structure hardly suggested what occupied its interior. John Vanoli booked nationally known troupes to perform on his stage, and the Jerome J. Johns Brass Band provided music. If the theatergoers wanted further "entertainment" afterward, they could hire a prostitute. Wallpapered cribs were located upstairs. (OCHS.)

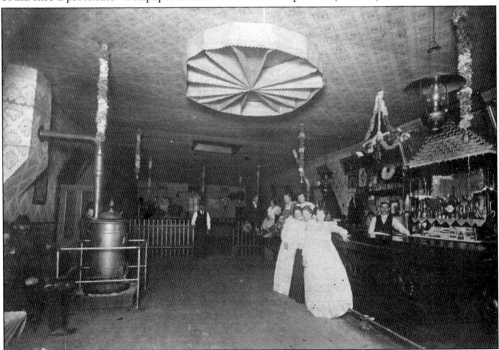

TEMPLE OF MUSIC. Located in the notorious red-light district, this brothel and dance hall offered 24-hour-a-day music and gambling. Roulette, faro, draw poker, and blackjack could take a miner's entire paycheck on a Saturday night. The Temple of Music's madam, Sadie Tabor, also ran a thriving business. The saloon burned in 1927. (OCHS.)

MILTON H. MARK. One of Ouray's early merchants, Mark operated the M. H. Mark Meat Market. He also served as town mayor from 1887 to 1889. His daughter Maude attended school at Piedmont, a small school north of Ouray. (Dorothy Randall.)

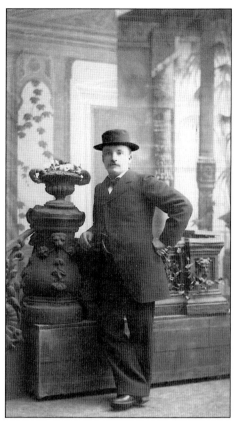

WRIGHT OPERA HOUSE. Ed Wright and his wife, Letitia, decided that Ouray needed a cultural center, and Ed hired Francis Carney to erect their opera house on Main Street. The two-story building had space for retail on the bottom and a hall on the top floor. A Mesker Brothers cast-iron front elaborately decorated its facade. Over the years, political speeches, basketball games, plays, proms, dances, and concerts constantly filled the hall. A sign on the front reads "Prof. Simpkins Social Dance To Night." (DPL, #63142.)

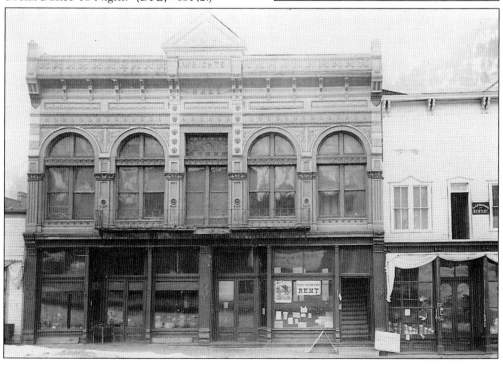

REV. J. J. GIBBONS. In 1888, Father Gibbons was assigned to a territory that was, in his words, the size of Ireland. He wrote of his experiences in his book *In the San Juan*. He had a reputation of riding his horses fast as he dodged avalanches, tended to the sick, and delivered the last rites to miners killed in explosions. His office was located in the Wilson Hotel. (OCHS.)

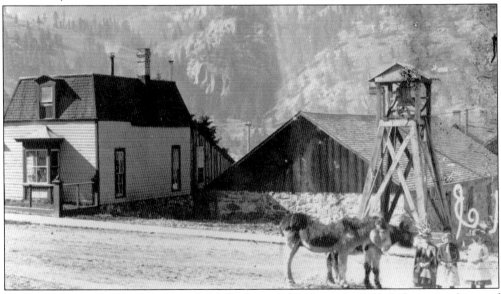

ST. JOHN'S EPISCOPAL CHURCH. Rev. C. M. Hoge moved to Ouray in 1877. A determined man of God, the evangelist visited saloons with a gun strapped around his cassock, cajoling the miners to pray. His congregation laid the cornerstone for St. John's in 1879. Welsh immigrants crafted the church with native stone. The church's bell tower was shipped from a foundry in Baltimore, but when Hoge left Ouray, he took the bell with him to Cortez. (OCHS.)

Five

A New Century

The 1900s witnessed the gradual decline of the mining era. An article by Samantha Tisdel Wright titled "Bye, bye Bird-ie" ran in the August 3, 1995, *Ouray County Plaindealer*. Mongolian Gold purchased the Camp Bird mill, and it was unceremoniously disassembled and shipped to Mongolia. By the last half of the 20th century, tourism was the town's economic mainstay.

The automobile made its appearance, and federal highway money widened Otto Mears's old toll road, now dubbed the Million Dollar Highway. Tourism became mainstream, and the scenic trip from Ouray to Silverton gained national attention. In the 1920s, a million-gallon hot springs swimming pool opened.

In 1927, a fire broke out that burned the Bon Ton and the Temple of Music and burned the Ashenfelter barns to the ground.

Prohibition hit the town hard. Government agents arrested Italian immigrants for making wine in their basements. Saloons became pool halls, and the red-light district faded into memory.

Supplying provisions to the mine's boardinghouses, however, remained profitable. Al Knous opened his market, giving the town its fifth grocery store. The Cascade Grocery Store opened by Fausson and Pricco operated for 60 years. Canavan's clothing store, the Busy Corner Drug Store, and the Sanitary Market filled Main Street buildings. Albert Schneider and Frank Massard's Post Office Drug Store sold patented medicines, and their soda fountain sold a "drink on a stick"—one of the earliest popsicles. Attorneys Carl Sigfrid and Lyman Henry built the Hayden Block building for their law offices. Around the time of World War II, the Zanett family opened the Blue Bird Bar and Café, and Christina Bonatti ran a pool hall and later a gift shop.

The first motel, Ouray Cottage Court, advertised rooms.

Retirees discovered the town nicknamed the "Switzerland of America" and brought new energy to the community.

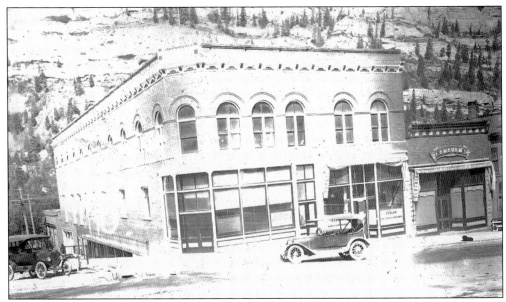

CITIZENS STATE BANK. In 1918, after Prohibition closed the Office Saloon, Citizen's State Bank purchased the handsome brick building at 600 Main Street. The original windows from the saloon are still used in the bank today. (OCHS.)

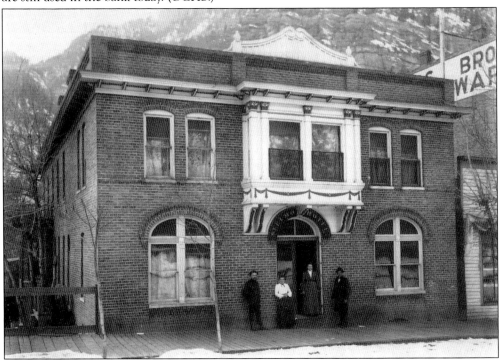

ST. ELMO HOTEL AROUND 1900. With the money she earned from operating her Bon Ton Restaurant, "Aunt" Kittie Heit built the St. Elmo Hotel in 1898. Heit took pride in offering a clean establishment with white linen on her tables, but Kitty was better known for her generosity to the miners and townsfolk. Her 1915 obituary read in part, "during her residence in Ouray she had been a regular 'mother' to hundreds, and no one could possibly be missed more than she." (DPL, #X-12722.)

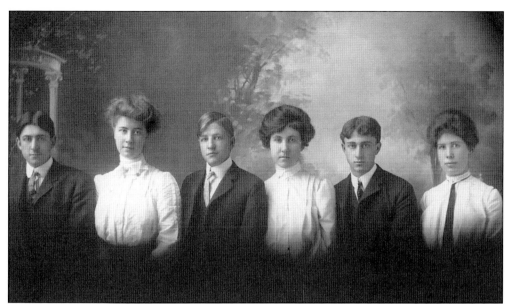

CORA ALMOND ORENDORF. Cora Almond graduated from Ouray High School with the class of 1904. A bright and imposing young woman, she attended Denver University and Colorado Normal School. She taught in the Ouray schools after graduation. In 1912, Cora married Marshall Orendorf. Cora kept the books for Marshall's various business enterprises. The Depression hit their businesses hard, and like dominoes, they began to fail. After Marshall's death in 1938, Cora lost their home. The next year, Cora ran for Superintendent of Schools on the Democratic ticket. She served in this position until 1948. Cora oversaw eight schools in Ouray County, and her days were spent guiding teachers, formulating budgets, and occasionally substituting in the classroom. Cora raised five children and had two grandchildren. Her granddaughter Constance Ruth remembered sitting in Cora's office; Constance had already learned to read by the age of three or four. The photograph above pictures the graduating class of 1904. Orendorf is second from left. (Both OCHS.)

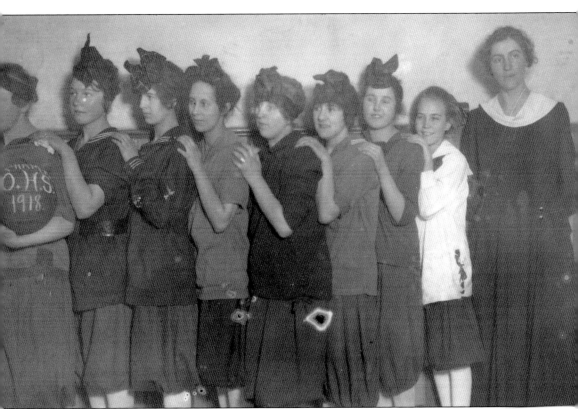

THE GIRLS OF 1918. The 1918 flu hit Ouray hard. The black crepe of death hung on doors; all mining activity stopped, and people wore rags over their faces in public. Scarlet Fever epidemics worried anxious mothers who protected their children by giving them a cod liver oil formula called Scott's Emulsion. World War I dragged on. In the midst of all this, Ouray enjoyed one bright spot: the girl's basketball team of 1918 came in second place in the spring tournament held in the opera house. Coached by Estatie Erickson (on right) the girls from left to right are Eva Anderson, Minnie Schneider, Dorothy Stebbins, Marguerite Childers, Norma Sonza, Elsie Ehinger, unidentified, and Helen Alexander. At the time of this photograph, Anderson's brother was fighting in the war. (OCHS.)

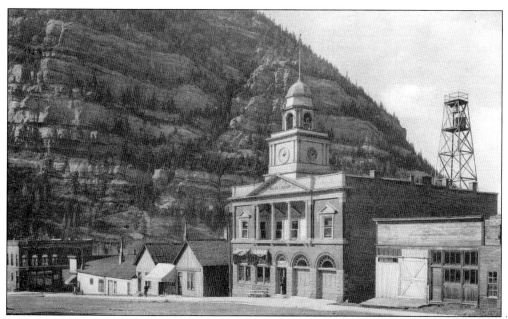

CITY HALL 1902. By the turn of the century, Ouray had a one-story brick and stone town hall with plans to eventually add a second story. Tom Walsh, his fortune in hand from the Camp Bird Mine, financed the project, and he donated 11,000 volumes to the top-floor library. He placed a natural history collection and specimens from surrounding mines in the new addition. On July 24, 1901, one hundred and thirty guests attended the dedication ceremony; many arrived on a special excursion train from Denver. (OCHS.)

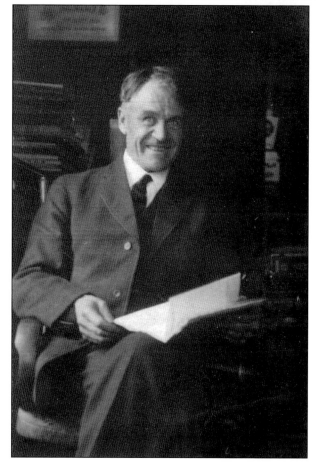

JUDGE WILLIAM RATHMELL. First a schoolteacher, Rathmell ran for county judge and was elected in 1896. His wife, Minnie, served as superintendent of schools. Rathmell loved history and spent two years writing his unpublished manuscript, *A Brief History of Ouray County, Colorado.* (OCHS.)

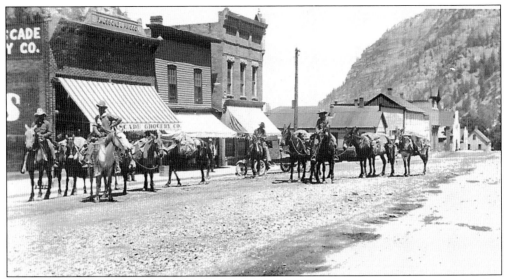

MAIN STREET, EARLY 1900s. The Cascade Grocery store, with its striped awning, opened in 1906. To the right of the grocery store was a restaurant, and on the end of the street, Pasqual's Saloon. On the corner of the next block stood John Asenfelter's office. The Roma Saloon, with its triangular-shaped roof, occupied the center of that street. The small truck tucked behind the pack train marked the beginning of a new era of transportation. (OCHS.)

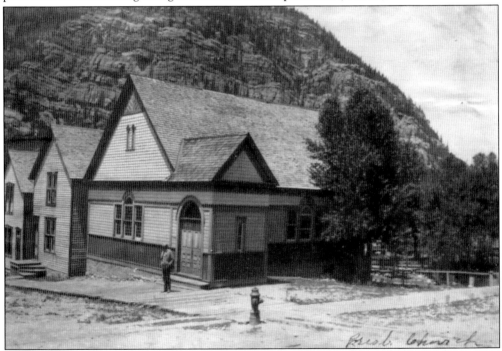

PRESBYTERIAN CHURCH AROUND 1900. In 1877, Rev. George Darley set out from Lake City, headed towards Ouray. Five days later, after struggling through a blinding snowstorm, he reached the town. Later that year, his congregation built a white-frame church on Sixth Avenue but lost it in foreclosure. The congregation kept their dream alive and built this fine new church in 1899. Here Reverend Darley stands on the boardwalk by the building. (First Presbyterian Church of Ouray.)

SAN JUAN BOTTLING WORKS COMPANY. In 1910, Fred Moscan and his partner, Ernesto Zanella, purchased the San Juan Bottling Works located on Oak Street. The business made and bottled beer until Prohibition, then turned to soda pop, ice cream, and near-beer. A tank used for carbonation leaned against the building. (Ruth and Marvin Gregory collection.)

BELVEDERE HOTEL. In 1910, Mary Moscon Fedel arrived in Ouray with her mother, Mary Moscon, and her new stepfather. Mary's parents bought a boardinghouse and catered to miners and railroaders. Mary met Frank Fedel in 1918, but the flu epidemic kept them confined so they could not date. Nonetheless, in 1919, the couple was married. In this image, Mary's two sons, Francis (left) and Al, stand in front of the Belvedere Hotel. Today this building houses the Coachlight Restaurant. (Joan Fedel.)

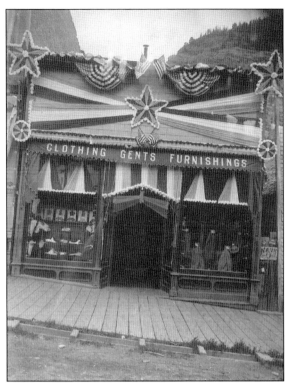

M. J. Canavan and Son. In July of 1889, James "Jimmy" Canavan came to Ouray. He had 10 years of experience as a storeowner and tailor in Leadville and opened a fine men's clothing store on Ouray's Main Street. Canavan's suits were fashionable, or "nobby." He brought fine clothing from Europe to the men of Ouray. Canavan was a friend of Thomas Walsh, and he was probably his tailor too. Thomas, Jimmy's son, became a partner in the store, and when Jimmy died in 1928, Tommy kept the business in operation. He had an artistic eye and took satisfaction in having his windows well-decorated. In the picture at left, he has trimmed his storefront for a special occasion, most likely the Fourth of July. Tommy Canavan also served as mayor of Ouray in 1923 and 1924. Canavan sold Styleplus suits "made on the thrift plan" during World War I. (Left, Michael Canavan; below, Ruth and Marvin Gregory collection.)

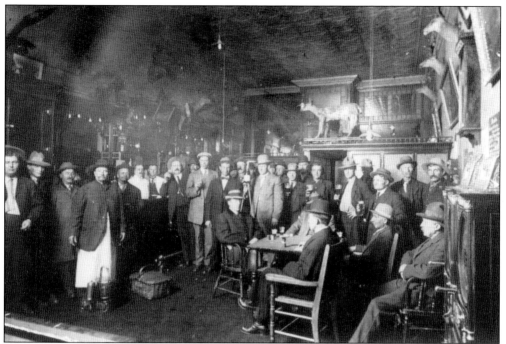

OMLAN, MANION AND COMPANY, THE OFFICE SALOON. Thanks to a clever bit of naming, Ouray men could honestly tell their wives that they were going to "the office" when they met their friends at their favorite drinking place. The saloon advertised that it was "one of the cosiest [sic] and most comfortable places in the San Juan in which to spend a pleasant hour." (OCHS.)

IN FRONT OF OFFICE SALOON, 1917. German immigrant Joseph Wühr (seated with cane) lost his eyesight in a mine explosion. His family wanted him to return to Germany, but he refused, saying that his good friends in Ouray would take care of him. This image shows the group of compatriots gathered in front of the Office Saloon. (Ruth and Marvin Gregory collection.)

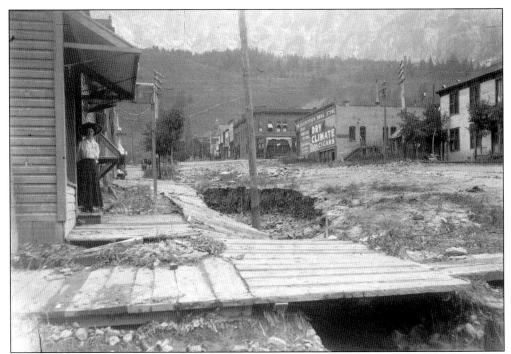

FLOOD OF 1909. On July 23, 1909, a torrent of water spread from Cascade Creek, overflowing into cellars and houses. Water furiously swept away bridges as mud and rocks filled the streets. Men on horseback rescued children trapped by the floodwaters. A woman stands on the sidewalk surveying the damage on Sixth Avenue. (Ruth and Marvin Gregory collection.)

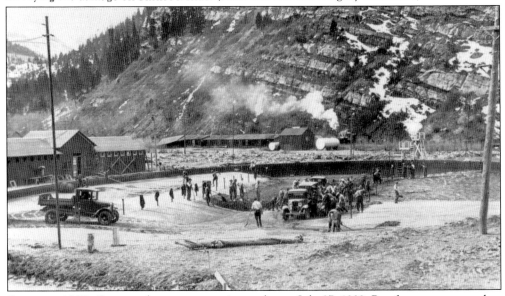

FLOOD OF 1929. Ouray woke up to an ominous sky on July 27, 1929. By afternoon, water shot straight out of Cascade Falls. The rain did not stop until the Uncompahgre River flooded and huge boulders rolled down Main Street. Skyrocket Creek filled the pool with muck and debris. Businesses closed for the community-organized cleanup; men shoveled the debris into pickups, and the Woman's Club served hot dogs and hamburgers. (OCHS.)

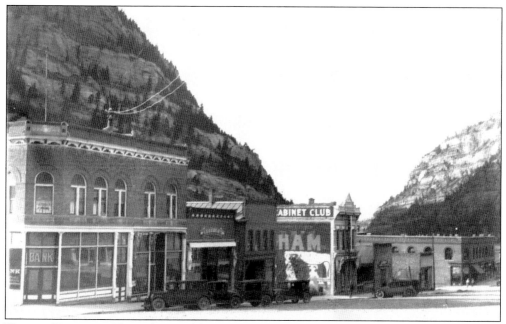

HEIBLER BUILDING. The Cabinet Club opened in the ornate, two-story building in the middle of the block. The respectable Thomas Hiebler and his madam wife, Sadie Tabor, ran the saloon. Tabor's life ended with a bullet in the head. The itinerant Tim Lynch shot Tabor in the head, then turned his pistol and shot himself. The reason for the murder was never determined. In later years, the building housed the Uray Theater. The building was torn down in the 1960s. (OCHS.)

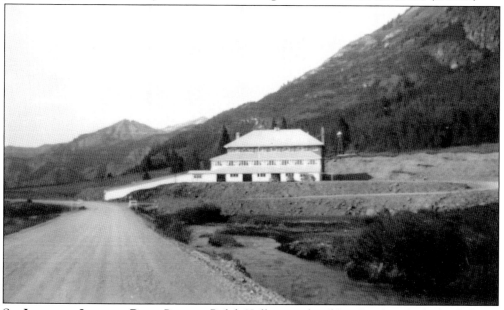

SKI LODGE AT IRONTON PARK. Partners Ralph Kullerstrand and Joe Condotti built this lodge in the 1930s. Their enterprise included enhancing Crystal Lake and erecting a ski lift. The bricks came from the smokestack of the Saratoga Smelter. The two partners had a falling out, and they never opened for business. The St. Germain Foundation (the "I Am" religion) bought the site in the 1940s. The building burned, but the stone basement still sits along the highway. (OCHS.)

Doc Bates. Dr. Carl Bates bought the Miner's Hospital from the Sisters of Mercy in 1920, and over the next 25 years, he ran Bates Hospital, opened the Busy Corner Drug Store, and operated a sanitarium called Radium Vapor Health Institute (today the Wiesbaden Hot Springs Spa and Lodging). When his son was born in 1939, nearly 50 residents signed a petition to name the new baby. The petition in part read, "We the undersigned citizens of Ouray respectfully request that your new son be christened Carl V. in honor of his illustrious daddy." Carl Jr. is in his father's arms as his dad shovels snow from the hospital's shed. (Left, Carl Bates Jr; below, OCHS.)

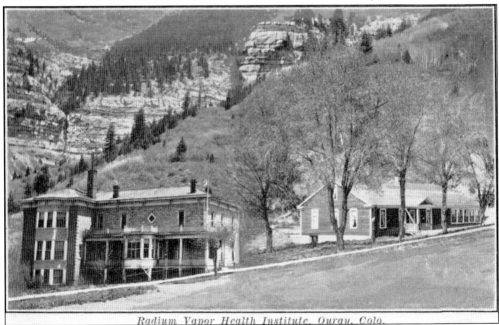

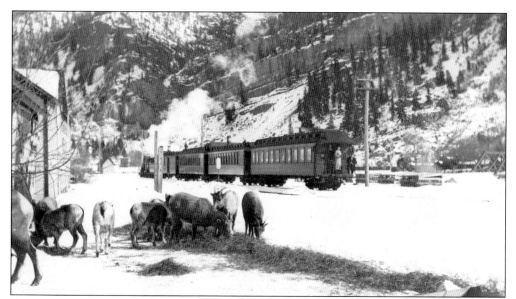

ROCKY MOUNTAIN SHEEP. Hay was brought in by boxcar for years to feed the mountain sheep during the winter. On occasion, the sheep would poke into the cars looking for a handout. To entertain the passengers, the conductor fed the sheep just as the train was leaving the station. (OCHS.)

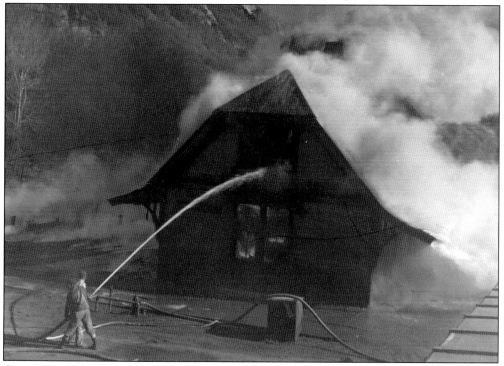

OURAY DEPOT DESTROYED BY FIRE. Spring runoff was in full force in 1948, and the raging water in the Uncompahgre washed out a power line north of town. When the line hit a telegraph pole, a short ignited a fire in the depot. Agent H. O. Anderson had left the depot for the night. The fire was discovered too late; the building burst into flames. The D&RGW replaced the depot with two converted boxcars, but the line was abandoned five years later. (OCHS.)

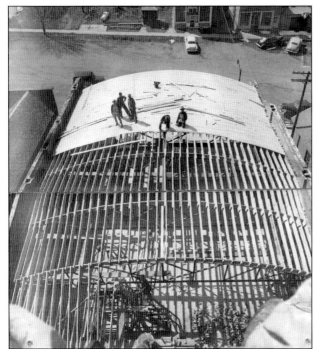

CITY HALL BURNS. An hour before midnight on January 27, 1950, a crowd stood in front of city hall, some with tears on their faces. Two streams of water poured on the flames, and fire trucks rushed in from Montrose, but the effort proved entirely inadequate. Only the frame of the once-fabulous building and the bell in the tower survived the fire. The Walsh Library had completely burned. In this picture, reconstruction has begun. (Joan Fedel.)

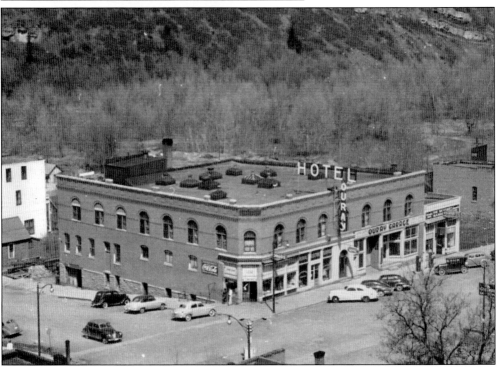

THE OURAY HOTEL. In 1945, when Charles Diller bought the Story Block, he changed the name of the hotel from the Wilson Hotel to the Ouray Hotel. The corner store in this c. 1948 photograph was Frank Massard and Albert Schneider's Post Office Drug Store. A garage complete with gasoline pumps occupied the north side of the building. (OCHS.)

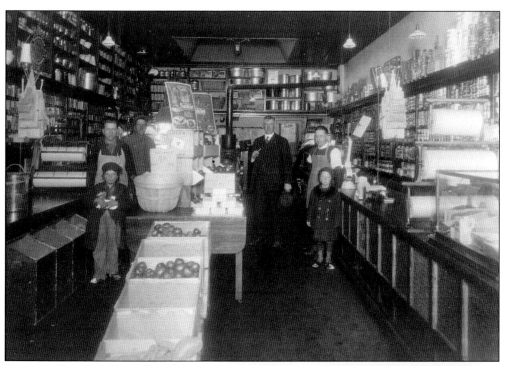

CASCADE GROCERY. Henry Zanella's Cascade Grocery sold candy, groceries, and even hardware. Families could place orders by calling phone No. 71, and a delivery boy brought sacks of groceries straight to their front door. (OCHS.)

SPACCA MONTAGNE (THE MOUNTAIN BREAKER). John Zanett (Giovanni Zanetti) arrived in Ouray in 1918 with his wife and children for a visit with his sister-in-law, Erminia Rossi. Erminia died in the 1918 flu epidemic. Zanett saw opportunity in the mines, and the family stayed. This 1952 photograph was taken in front of the Blue Bird Bar and Café, a restaurant he owned with his wife and sons. The rebuilt green stucco City Hall stands at left in the picture. (Bud Zanett.)

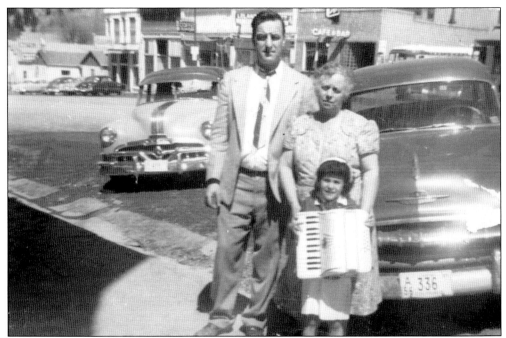

BONATTIS. Christina and Joe Bonatti opened Joe's Pool Hall at 600 Main Street in 1937. After Joe's death, Christina continued to run their establishment, a favorite gathering place for the city's teenagers. In this picture, Christina stands in front of her business with her son Rudy and granddaughter Chris. Across the street stood the Phillips 66 gas station and bus depot. (Chris Bonatti.)

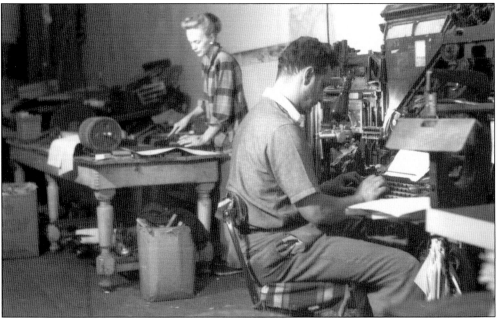

JOYCE JORGENSEN. Editor and publisher of the *Ouray County Plaindealer*, Joyce Jorgensen was also an accomplished painter and sculptor. She opened the first gallery in Ouray, encouraging the community to support the arts. In 1961, Jorgensen organized and directed The Alpine Artist's Holiday, an event still held in July. (OCHS.)

Six

RECREATION AND CELEBRATION

THEN AND NOW

With the San Juan Mountains in their backyard, outdoor recreation filled Ouray residents' leisure hours in both summer and winter.

The Denver and Rio Grande advertised itself as the "Scenic Line of the World," and railway passengers and special excursion trains brought profit to the line.

Saloons closed during the quiet Christmas holidays while miners spent time with their families, but the Fourth of July celebrations were loud and enthusiastic. The traditional Fourth of July festivities started during the town's earliest years. The holiday lasted two or three days, and preparations for the events could take months. Excursion trains brought spectators to town from as far away as Grand Junction. Bands and fraternal organizations marched in the morning parade with businesses and political candidates. Blasts from explosives set off in the mountains reverberated through the city. Children's activities were much anticipated—sack races, coins in sawdust piles, and pie-eating contests filled the afternoon, while formal dances at the Beaumont Hotel and informal dances at the Wright Opera House filled the evenings.

Fraternal organizations and lodges provided fellowship and support to men who had left their native lands. If a miner did not have a family, a lodge building offered him a place to feel at home, to play cards, and to visit with friends. They sponsored social events, lectures, and dances. Lodges offered life insurance and burial policies.

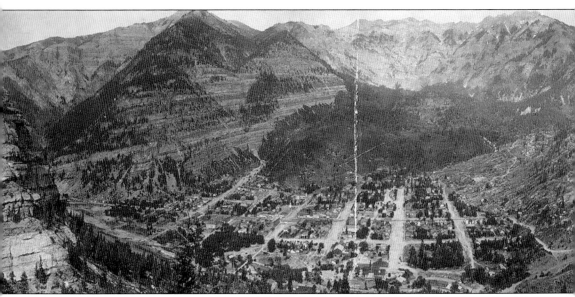

OVERVIEW OF OURAY, 1910. Otto Mear's toll road appears as a vertical slash to the right of the city. The highlight of the well-advertised "Circle Route Tour" (shown on the cover) was the six-hour Concord stagecoach ride from Ouray to Silverton. Ouray was advertised as the "Gem of the Rockies." Passengers looked out for prospectors on burros and marveled at the aerial tramways.

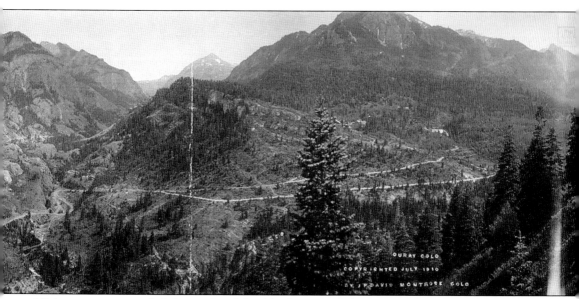
Highway crews expanded the road as federal highway funds became available, and the Million Dollar Highway was officially dedicated in July of 1924. This photograph was taken by J. P. Davis, who had a studio in Ouray. (Rick Trujillo collection.)

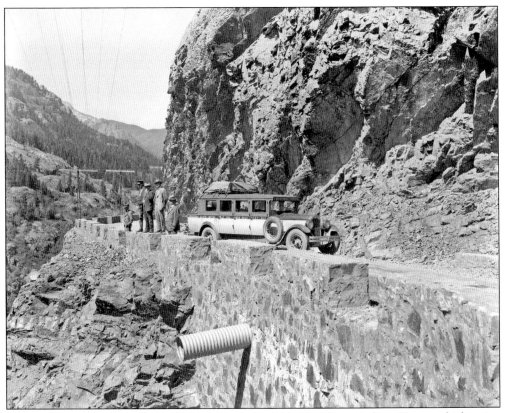

"Scenic Tour" Motorways Bus. Bus passengers gaze into the Uncompahgre Gorge, a frightening drop off the edge of the Million Dollar Highway. Automobiles and buses quickly replaced stagecoaches and wagons once the road was widened. Today a million visitors a year travel this scenic route. (DPL, #GB-5320.)

New Bicycles. Formal photography portraits were popular in mining towns around 1900. This couple brought their bicycles to the studio. With Ouray's steep and unpaved streets and no gears on their bicycles, it is unclear where they rode them. (OCHS.)

SIGHTSEEING, 1930s. What the woman is looking at is unknown, but the weathered remains of mills and mining camps dotted the hillsides. Wildflowers flourished in the late summer months, and elk, mule deer, and mountain sheep migrated to lower elevations in the winter. (OCHS.)

RIDING THE TRAILS. After pack trails and wagon roads were abandoned, motorcycle and four-wheel drive enthusiasts claimed the hundreds of miles of harrowing backcountry roads. Ouray boasts the title "Jeep Capital of the World." (OCHS.)

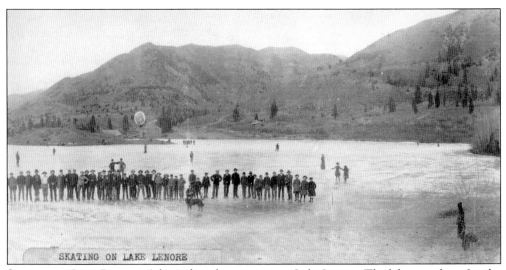

SKATING ON LAKE LENORE

SKATING ON LAKE LENORE. A line of ice skaters poses on Lake Lenore. The lake was about 2 miles below and east of Ouray and, by foot, a long, arduous hike. The skaters built bonfires to warm up chilled feet. The circle to the back of the lake marks the sight of a less wholesome adventure. George Wettengel, a brothel owner in Ouray, decided to open up a branch operation near the busy mines on Gold Hill. He named the lake "Lenore" after one of his favorite girls. (Ruth and Marvin Gregory collection.)

FISHING, LAKE LENORE. Under the watchful eye of their mother, these two children throw a line in the lake. The lake was stocked with native and rainbow trout. Today, the lake is located in a privately owned community. (OCHS.)

NELLIE RATHMELL GOES SKIING. Skiing, called snowshoeing, was not just sport, but a practical way of getting from place to place. The pole, about eight feet in length, guided Nellie down the slope. Usually homemade out of leftover wood, skis were 8-to-12 feet in length and about 5 inches in width. (OCHS.)

SNOWY SLEDDING PARTY. The Elks Club members closed off three or four of the steepest hills in town so the youngsters could have a good run. The first sleds were made from drill steel, shaped by a blacksmith, with a plain board placed on top. During the Depression years, a relief truck delivered brand new snowsuits to impoverished children. (OCHS.)

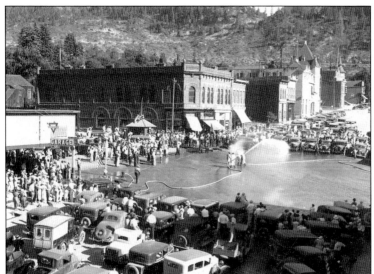

WATERFIGHT, JULY 4, 1935. Teams took their places, aimed their fire hoses, and at the signal, the water was turned on. Water-soaked spectators cheered the contestants on until one of the teams abandoned their hose. The celebration continued with sack races, drilling contests, greased pig races, and a pyrotechnic display at sundown. (OCHS.)

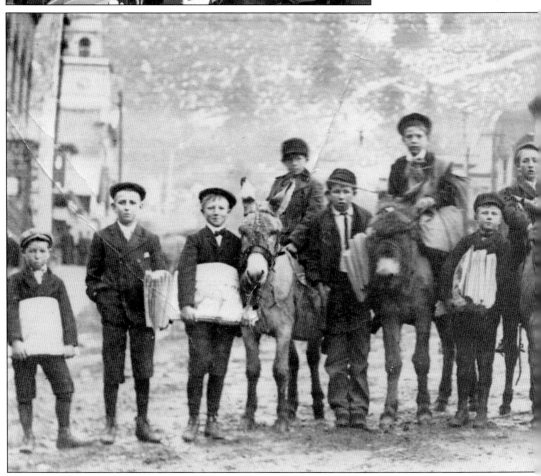

NEWSPAPER BOYS. Lined up on Sixth Avenue, *Denver Post* carriers wearing newsboy caps held up copies of the New Year's Day edition. The boys were paid $1.00 to $1.25 a week. Pet burros and baby

HALLOWEEN, AROUND 1920. On this lonely Halloween night, pranksters borrowed outhouses from backyards and placed them in the middle of Main Street. (OCHS.)

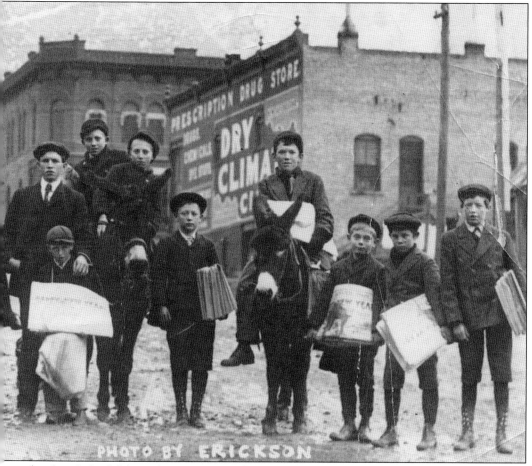

brothers helped deliver the papers. Most boys went to work in the mines by the age of fourteen. (Ruth and Marvin Gregory collection.)

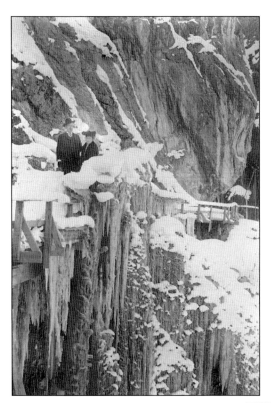

BOX CANYON. A natural wonder formed from upheaval, glacial action, and erosion, Box Canyon intrigued these hikers. The footbridge seen from the boardwalk is 402 feet above the floor of the canyon. The site was first owned by Ouray pioneer Edward McIntyre. The city leased Box Canyon for a time, and after McIntyre's death in 1920, the family gave Box Canyon Park to the city of Ouray. (OCHS.)

HIKING TRAIL FROM HIGH BRIDGE. In August of 1903, these hikers worked their way down a trail from the high bridge at Box Canyon by hanging onto the pipe that ran water to the town's hydroelectric plant. The following names were written on the back of the photograph: Mr. Frakes, George Wright, Mr. Parkins, Mrs. Parkins, Mrs. Herring, and "Young" Parkins. Today hikers enjoy this breathtaking view while trekking Ouray's Perimeter Trail. (OCHS.)

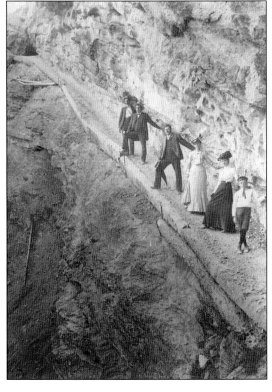

WOMEN'S HORSEBACK RIDE. Women riding sidesaddle with tailored riding habits pose on Vinegar Hill. When riding in the high mountains and with no men accompanying them, women donned more practical clothing and rode astride with divided skirts. Livery stables rented horses or burros if a rider did not own one. (OCHS.)

BRIDGE OF HEAVEN. With a drop of over 1800 feet, this section of Horsethief Trail frightened even experienced riders. The legend of the trail tells the story of horse thieves who, in the early days, stole horses in the San Luis Valley and drove them over the trail into Utah's Blue Mountains. (OCHS.)

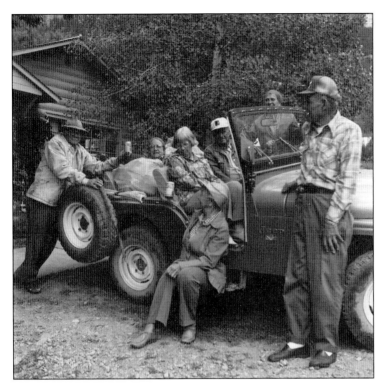

WOMAN'S CLUB. In the late 1970s, members of the Woman's Club gathered aluminum cans to raise money for an elevator in Ouray City Hall. Established in 1897, the Ouray Woman's Club has actively supported the community ever since. The club was instrumental in establishing the library, beautifying the cemetery, supplying thousands of trees for the replanting of the forest near the Molas Divide area, and getting the Million Dollar Highway improved for auto traffic. (OCHS.)

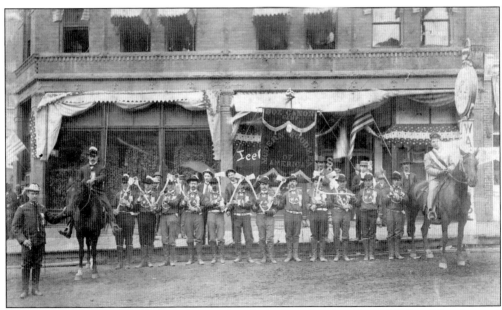

MODERN WOODMEN OF AMERICA. Axes in hand, the Box Canyon Camp Modern Woodmen of America pose in front of the Hess Stanislawski Building, ready to march in a 4th of July Parade. A group of 30 men initiated the organization in 1900, and by the end of the year, 90 members were on its rolls. The group held balls and social events and leant support to one another. (OCHS.)

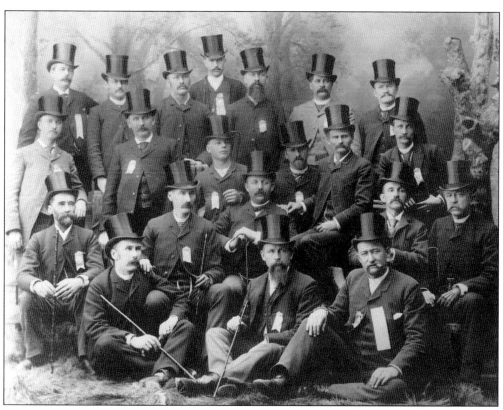

ELK'S CONVENTION. Elks Lodge No. 492 hosted the 1911 state Elks convention, and participants posed for this formal picture. When they dedicated their new lodge building in 1905, a three-block-long parade stretched from the depot to the new lodge, and practically every building in town was decorated in Elks colors: purple and white. The Ouray chapter is the oldest Elks Lodge on the Western Slope. (OCHS.)

CHRISTMAS GIFT FROM THE ELKS, 1977. Since the 1930s, Ouray Elks Club Santas filled their sacks with candy and fruit, and on Christmas Eve, delivered their gifts to local children and to senior citizens without families. Sleigh bells tinkled as sleds made their way from house to house. In later years, Santa arrived by SUV. This man was staying in the Ouray Hotel when Santa came. (OCHS.)

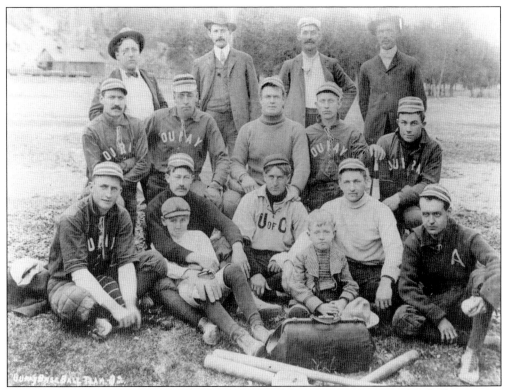

BASEBALL AND SMOKY JOE WOOD. Between 1900 and the Great Depression, baseball was in its prime. Ouray townspeople traveled to away games; Silverton was their greatest rival. Joe Wood is the young man with the cap at the bottom of this 1902 photograph. "Smoky" Joe went on to play major league baseball. At the age of 22, he won 34 games, including 10 shutouts, and a string of 16 consecutive victories, which tied an American League record. (OCHS.)

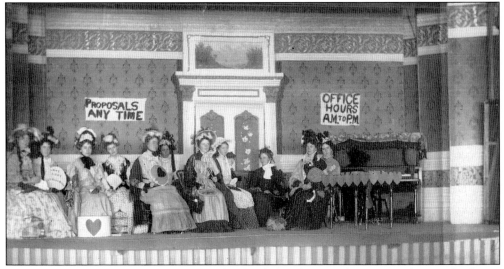

OLD MAIDS CONVENTION. Ouray High School girls lined up on the stage at the Wright Opera House for their play, *Old Maids Convention*. Nellie Holaday, a teacher at the school (right), sponsored the 1903 production. (OCHS.)

PLAYING COOTIE. In September of 1956, Ouray High School students gathered at Dawn Kier's house to play the board game, Cootie. From left to right are Lee Anna Duckett, Phil Icke, Jimmy McAboy, Dawn Kier, and Bill Stark. (Phil Icke.)

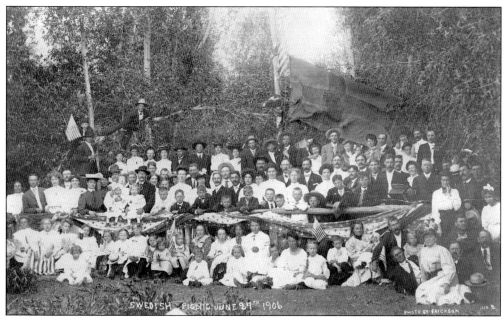

SWEDES PICNIC. A tightly knit community that enjoyed celebrating their heritage, Ouray's Swedish immigrants gathered for this picnic in the summer of 1906. A blue and yellow Swedish flag flew with the Stars and Stripes above. The surnames Forsman, Lindquist, Sederholm, and Grabow were penciled on the back of this photograph. (OCHS.)

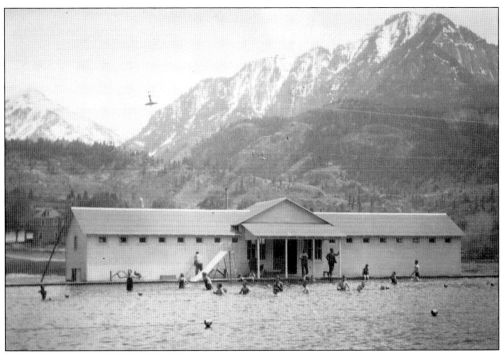

HOT SPRINGS POOL. Constructed in 1925, the million-gallon hot springs pool drew people from surrounding towns. The 1929 flood destroyed the original tents used for bathhouses, and this new frame bathhouse replaced the tents. After World War II, the name "Radium" was officially dropped. (Southward collection.)

BATHING BEAUTIES AT THE POOL. On a cold winter day, these young women are ready to take the plunge into the pool. They wore basic tank suits probably made of wool that were popular from the late 1920s to the mid-1930s. The suits were unisex. It was not considered proper for men to go topless until the late thirties. (OCHS.)

WHO'S SHOOTING WHOM? With their new Kodak Brownie cameras, these young men watch as their female companion aims at the unseen cameraman. (OCHS.)

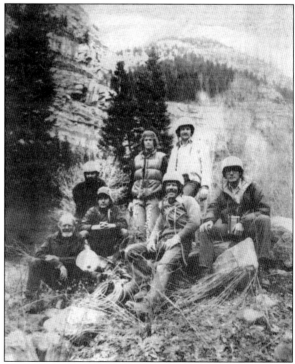

MOUNTAIN RESCUE TEAM. With the onslaught of visitors to the high country, the necessity for a rescue squad became unquestionable. In 1976, the Mountain Rescue Team gathered for a fund-raising event. Seen in this photograph from left to right are (first row) Kurt Kircher, Bob Zimmer, Mike Hamrick, and Rick Trujillo; (second row) Elwood Gregory, John Tjossem, and Doug Walker. (OCHS.)

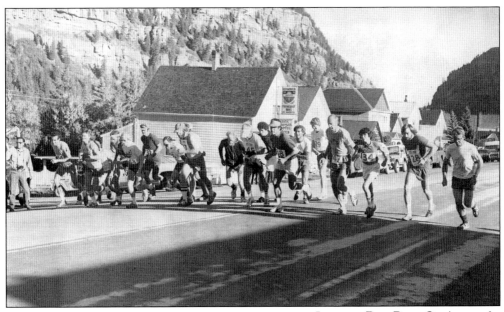

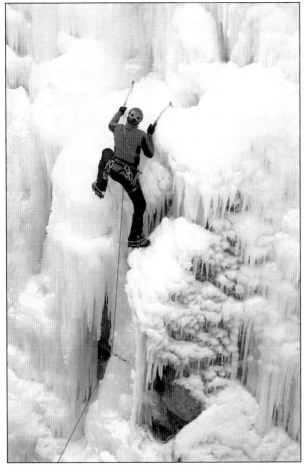

IMOGENE PASS RUN. On August 6, 1974, Rick Trujillo was in training for the Pike's Peak Marathon when he decided to run over Imogene Pass, a jeep road that runs from Ouray to Telluride. The long-distance "Imogene Pass Mountain Marathon" took off. The annual race held in September covers a distance of 17.1 miles, and the pass climbs to over 13,100 feet. Around 1200 runners participate. The race begins on Main Street in Ouray. (Rick Trujillo.)

OURAY ICE FESTIVAL. The icy gorges south of Ouray provide challenging competition to ice climbers. Since 1996, male and female ice climbers, both locals and from around the world, have gathered at the Ouray Ice Park in January for the event. (Paul McCreary.)

Seven

HISTORIC RESEARCH AND PRESERVATION

In 1983, Ouray received designation as a National Historic District. The city has retained much of its Victorian architecture, and the Ouray Chamber and Resort Association notes that two-thirds of Ouray's Victorian buildings are still occupied, many of them carefully restored. Mesker Brothers ornamental sheet-metal and cast-iron fronts embellished commercial buildings in the late 1800s and early 1900s, and Ouray has one of the largest number of buildings with Mesker fronts in the United States.

Examples of private and public historic projects include the restoration of the Ouray City Hall facade, the renovation of the county courthouse, and the renovation of the Beaumont hotel, the Story Block, and the Poor Farm.

Local oral history projects and archaeological research, as well as the collection of artifacts and photograph and paper archives housed in the Ouray County Museum, document the city's unique history. The Red Mountain Project targets the endangered Red Mountain District. Historic preservation and research remain an ongoing concern.

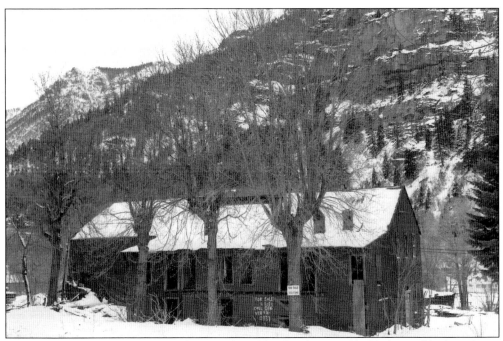

VANOLI SITE. From 1881 to 1915, John Vanoli and his family owned half of a city block in Ouray that housed his "sporting complex." The site included saloons, gambling dens, bathhouses, a Chinese laundry, cribs, and the Gold Belt Theater (above 1981). The Gold Belt sat empty for years after 1915, almost hidden on its back lot near Eighth Avenue. In 1970, Steve Baker began a research program on the site that lasted for 11 years with big excavation pushes in 1975 and 1981. According to Baker, "We recovered a veritable time capsule of many thousands of artifacts." In the photograph below, the crew is excavating a privy. The uncovered artifacts reflected life in a sporting district and indicated heavy drug and alcohol use. Baker also did primary historical research and collected oral histories from people who remembered the complex. The Gold Belt was demolished shortly after the above picture was taken. (Both copyright © 1981 by Steve Baker, Centuries Research, Inc.)

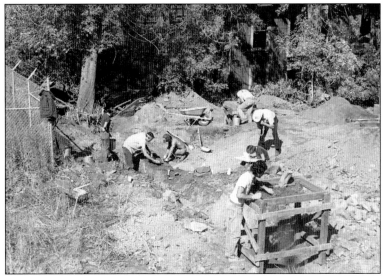

SEARCHING FOR CHIEF OURAY'S HOME. Two well-known 19th-century photographers chose to photograph the ruins of an adobe structure located near the present-day Wiesbaden Hot Springs Spa and Lodging. The photograph on the right, from the William Henry Jackson collections, shows a small two-roomed adobe house labeled "Ruins of Chief Ouray's House." In 1988, Steve Baker conducted a field project at this site. He found a small puddle adobe structure underneath a cottage on the Wiesbaden property near the hot springs. In 2003, grant funds were obtained, allowing Baker to further investigate. By doing a comparative study of all available photos, studying archaeological remains, and conducting historical and geological research, Baker concluded that the site was likely Chief Ouray's seasonal hunting place. It was most likely built prior to the Brunot Agreement of 1873. (Right, DPL, #WHJ-916; below, copyright © 1995 by Steve Baker, Centuries Research, Inc.)

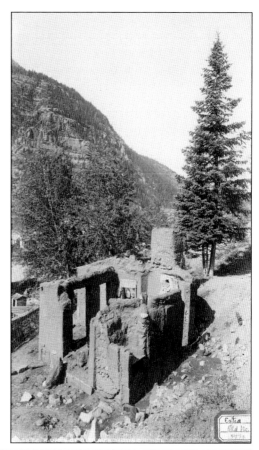

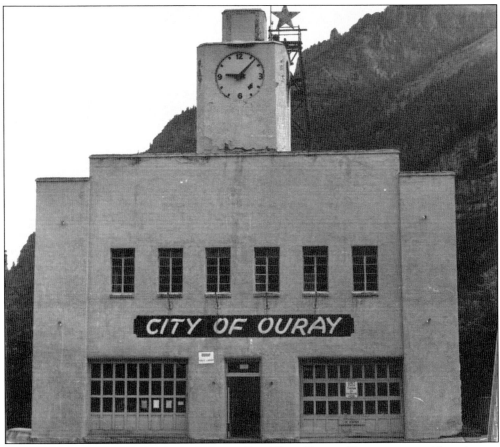

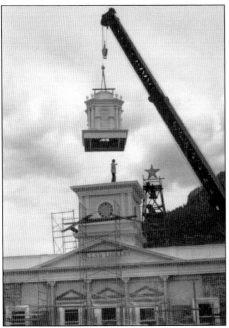

CITY HALL FACADE RESTORATION. After city hall burned in 1950, the building's facade was replaced with a green stucco front. It was the dream of several community members to restore the facade. The original front was designed to resemble Independence Hall in Philadelphia. In 1976, the year of the city's centennial, a committee's efforts to restore the facade failed. Then, in 1986, Ouray elected Bill Fries mayor. Fries (who under the name C. W. McCall had written and recorded the 1970s smash "Convoy") asked the city council's support for the project, and the idea again got off the ground. Donations from individuals and businesses flowed in until the needed $100,000 was raised. Walt Rule wrote a series of articles of city hall memories that were published in the newspaper. On July 4, 1988, the city hall committee dedicated the new facade at a ceremony in front of city hall. On August 11, 1988, the clock and bell towers were lifted by crane and set atop the building. (Both Walt Rule.)

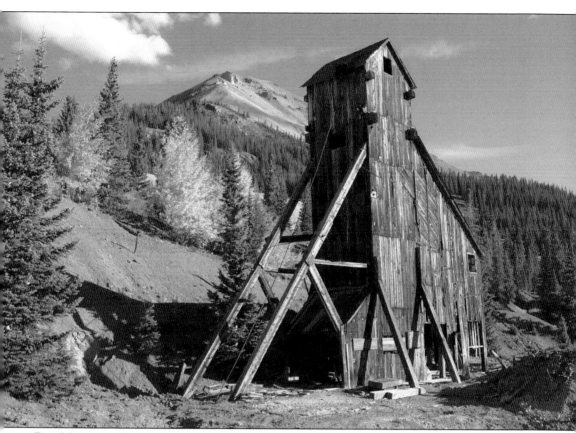

RED MOUNTAIN TASK FORCE. Only a few dozen buildings remain in the ghost town ruins of the Red Mountain district where 3,000 people once lived. In 1998, local historic preservation groups and concerned citizens, as well as the Trust for Public Lands, joined together to form the Red Mountain Task Force to preserve and protect the area. Most of the land was privately owned and possibly in danger of development. The National Trust for Historic Preservation named the district one of the 11 most endangered regions in the country. With the help of Colorado's congressional delegations, Congress approved $14.1 million in Land and Water Conservation funds to purchase property from private owners. In addition, several owners donated their land to the Project. All of these parcels were then transferred to the National Forest Service and are protected from development. The task force area includes approximately 36 square miles, and stabilization of historic structures is an ongoing concern. The Yankee Girl headframe (above) was stabilized with grant funding. (Don Paulson.)

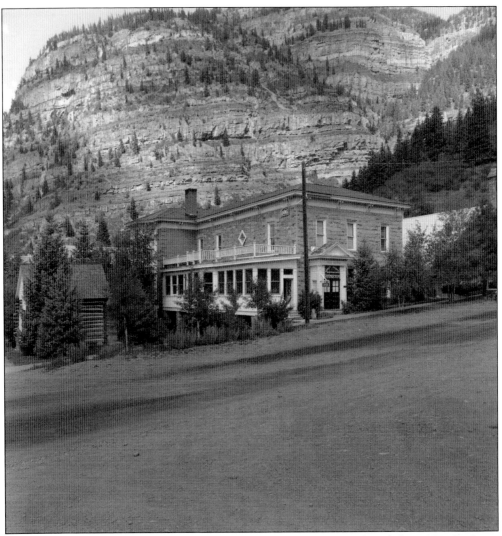

OURAY COUNTY MUSEUM. The Ouray County Historical Society was founded in 1971 after Joyce Jorgensen, editor of the *Ouray County Plaindealer*, encouraged the community to preserve its local heritage. Artifacts and old photographs needed to be identified and preserved. St. Daniel's Catholic Church Parish Council offered to loan the old St. Joseph's Hospital building to the society. In 1976, the society purchased the building from the Bishop of Pueblo. Three floors in the museum hold collections from Ouray County's mining, ranching, and railroading past. A research center contains thousands of photographs and paper archives as well as the Ross Moore Mining History Library. (OCHS.)

SELECTED BIBLIOGRAPHY

Baker, Steven G. "A Thirty-Year Perspective on the Uncompahgre Valley Ute Project, Western Colorado." *Society for Historical Archaeology Newsletter* 40, No. 4 (Winter 2007): 31–47.
Brown, Robert L. *An Empire of Silver.* Denver: Sundance Publications Limited, 1984.
Brown, Ronald. *Hard-Rock Miners The Intermountain West 1860–1920.* College Station, Texas: Texas A&M University Press, 1979.
Crum, Josie Moore. *Ouray County Colorado.* Durango, CO: San Juan History, Inc, 1962.
Decker, Peter R. *The Utes Must Go.* Golden, CO: Fulcrum Publishing, 2004.
Gregory, Doris H. *The Great Revenue and Surrounding Mines.* Ouray, Colorado: Cascade Publications, 1996.
Gregory, Doris H. *History of Ouray: A Heritage of Mining and Everlasting Beauty.* Ouray, Colorado: Cascade Publications, 1995.
Gregory, Doris H. *History of Ouray: Historical Homes, Buildings and People.* Ouray, Colorado: Cascade Publications, 1997.
Hoffman, Ann C. *Ouray's Historic Main Street. Early Visions Wild Times.* Ridgway, Colorado: Country Graphics/Wayfinder Press.
Howard, George, unpublished diary.
Marshall, John, and Zeke Zanoni. *Mining the Hard Rock.* Silverton, Colorado: Simpler Way Book Company, 1996.
Meyerriecks, Will. *Drills and Mills,* Second ed. Tampa, Florida, 2003.
Moore, George E. *Mines, Mountain Roads and Rocks.* Ouray, Colorado: Ouray County Historical Society, 2004.
Nossaman, Alan. *Many More Mountains, Volume 1: Silverton's Roots.* Denver: Sundance Publications, Limited, 1989.
Rice, Frank A. *The Mines of Ouray County.* Ouray, Colorado: Bear Creek Publishing Company, 1980.
Rosemeyer, Tom. "Camp Bird Mine Ouray County, Colorado." *Rocks and Minerals* 65, No. 2 (March/April, 1990): 114–149.
Sagstetter, Bill, and Beth Sagstetter. *The Mining Camps Speak.* Denver: BenchMark Publishing of Colorado, 1998.
Sloan, Robert E., and Carl A. Skowronski. *The Rainbow Route An Illustrated History of The Silverton Railroad, The Silverton Northern Railroad and The Silverton, Gladstone and Northerly Railroad.* Silverton, Colorado: Sundance Publications Limited, 1975.
Smith, P. David. *Mountains of Silver.* Boulder, Colorado: Pruett Publishing Company, 1994.
———. *Ouray: A Quick History.* Fort Collins, CO: First Light Publishing, 1996.
Smith, Duane. *Rocky Mountain Mining Camps The Urban Frontier.* Lincoln: University of Nebraska Press, 1967.
Turner, Leigh Block. "On Being a Child In a Little Mountain Town." *Colorado Heritage,* (Summer, 1991): 2–19.

Discover Thousands of Local History Books Featuring Millions of Vintage Images

Arcadia Publishing, the leading local history publisher in the United States, is committed to making history accessible and meaningful through publishing books that celebrate and preserve the heritage of America's people and places.

Find more books like this at
www.arcadiapublishing.com

Search for your hometown history, your old stomping grounds, and even your favorite sports team.

Consistent with our mission to preserve history on a local level, this book was printed in South Carolina on American-made paper and manufactured entirely in the United States. Products carrying the accredited Forest Stewardship Council (FSC) label are printed on 100 percent FSC-certified paper.